Booth-Clibborn Editions

First published in paperback 1996

First published in 1995 by
Booth-Clibborn Editions
12 Percy Street
London W1P 9FB

Printed and bound in Hong Kong by Toppan Printing Company

ISBN 1-861540-205

Distributed world-wide and by direct mail through
Internos Books
12 Percy Street
London W1P 9FB

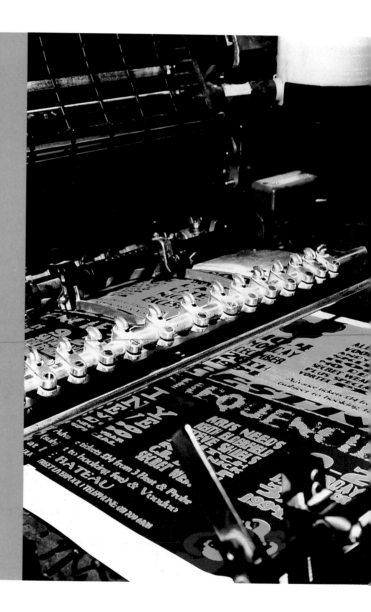

Book design . Nonconform
Project co-ordinator . Brian Parkes
Compilation and project assistance . Phil Beddard, 3 Beat Music
Original photography . Mark McNulty
Additional photography . Anne Pownall
Introduction . Jon Savage
Conclusion . Stephen Kingston
Model . Fiona McNulty
Design editor . Liz Farrelly, Booth-Clibborn Editions

Acknowledgments .
Thanks to . Trevor Johnson. Pez. Chris Waring. Skinner. Jill and Sonia.
Mark, Renaissance. Michelle Woolf. Robin Jackson. Jon Barlow. Philip
Southall. Andrew Weatherstone. Philip Casey. Ian Whittaker. Katherine
Heldt. Michelle Durkin, HIT. Andy, Fatcat. Rebecca Seager. Paul Hunter.
Darren Hughes, Alan Green and James Barton, Cream. Bernie and Ruth.
Ben Turner and Push, Muzik. Louise Morgan. Sarah Bolden. Richard
Maides. Richard Norris. Deborah and Rick, Puscha. Peter Kelly. Bill
Brewster, DMC. John Draper, The Haçienda. Harry, Rick, Pete and Simon
and all, DIY. Sara Blonstein. Craig Richards and Chris Priest, Malibu Stacey.
Mark Farrow. Howard Wakefield and Peter Saville. Ian Anderson. Chris
Mellor, DJ. Will Tang, Adrenalin. Michael Dog. Simon and Russell. Jason
Brookes. Madge, Madark. Craig Johnson. Thomas McCallion and Thomas
Lardner. Luvdup. Paul Fryer, Suzy and Nick Raphael, Vague. Nick Gundill.
George Georgiou. Leah, Glitterati. Paul Shurey, Club UK. Paul Oakenfold.
Jamie Reid. Sam and Skitch, Voodoo. Mixmaster Morris. Jon Hill, Golden.
Andrew Grahame, Goodtime. Christopher Ferguson, Dream FM. Terry
Farley. Lynn Cosgrove, MOS. Danny Shergold, BPM. Matt Valenzuela,
Dynamix. Pezz, 3 Beat. Rob, Joe and Tom, Ark. Robbie Ellis, Back to Basics.
John Kelly. Simon Sprince. Andrew Weatherall. Micky Lynas. Carl, Quest.
Kingsley and Dorothy, Roast. Dave Nicoll. Judy Weinstein, Def Mix. Andrew
McGovern. Jenni and Danny Rampling, Selective. Mixmag. Martyn
Rainford. Terry Fitch. Scooby, Trax. Claire Berliner. Matt. Phil Gifford,
Wobble. Tim Pearson. Jim, Verso. Lewis Blackwell, Creative Review. Rollo.
Helen Storey. Dr. David Mellor and Hillegonda Rietveld. Fraser Clark. Danny,
Flying Squad. Mark Sullivan, Dry. Kerry, Ultimate. Faye Somerville, V&A.

Special Thanks to . Leo Elstob. Matthew Acornley. Dave Beer.

"I am, you see, I am the creator and this is my house. And in my house there is only House music. But I am not so selfish, because once you enter my house it then becomes *our* house and our House music. And you see, no-one then owns house, because House music is a universal name spoken and understood by all; you see, House is a feeling...."
Chuck Roberts for Fingers Inc, "Can You Feel It" (1988)

This book exists to collect and celebrate selected ephemera from the post-House dance culture of the last nine years: an undertaking often seen as contradictory, if not pointless. You can see the complaint coming: "How can you put something so transient in a book ?". But transience is one founding dynamic of British Pop - as defined by Richard Hamilton[1] - and does not preclude another time scale: the real story of people's lives is not to be told in news headlines, but in the stuff of everyday. Because it freezes the moment, the ephemeral can be perennial.

Club flyers are an integral part of the urban landscape. Visit any youth-cult shop, and you will find a flat space covered with a bewildering array of visual input - a rapid, constantly changing form of communication. The baseline for any flyer is information - who, when and where - but the sheer volume of this cheap, quick turn-around medium has resulted in other effects. Produced by club communities, flyers are aspirational adverts, bulletin boards, in-jokes, showcases for young designers, a visual call and response for a whole generation. As *DJ Magazine* noted in April 1994: "They don't always tell the truth (but) they are our history". Here is one way of telling the story of the last nine or ten years, a period which has seen, in the UK and Europe at least, the musical focus of pop shift from rock to dance music - a fact which is as obvious as it is still often denied.

The images that you see in this book have a common origin: the sequence of minimal, spacey records that came out of the US from 1986 on. In early manifestos like "Can You Feel It" by Fingers Inc, "Freedom" by the Children, db's "I Have A Dream", and Marshall Jefferson's "Move Your Body", you can hear an inclusive warmth that comes from a strong sense of community - a feeling which, as Chuck Roberts' rap prophesied, has spread around the world to create other communities, one nation united under a House groove. As Jamie Principle whispered on his epic "Baby Wants To Ride": "I believe! I believe! Do you believe? I believe!".

For the last 30 years, pop music has travelled back and forth across the Atlantic in a series of bizarre mutations. Who could have predicted Kraftwerk's influence on the black dance music of 1981-1984, Hip Hop and Electro? Stigmatised and ignored in America because of its gay black origins, House readily travelled to Britain, where its "four on the floor" kick and synthesised melodies fed right into the uptempo aesthetic already established by Tamla, Northern Soul, Disco and Hi NRG. Collated and packaged by London Records, House quickly became big news from mid-1986 on, with massive hits by Farley "Jackmaster" Funk ("Love Can't Turn Around) and Steve "Silk" Hurley ("Jack Your Body": number 1 in the charts, January 1987).

House has the gospel spirituality and heart-stopping intensity of life that you hear in the best dance music, together with a certain gay-derived sense of melodrama, but it has added something new to this perennially popular mix: a profound sense of space. This comes directly from the club which gave House its brand name: in restructuring records for his dance floor, Warehouse DJ Frankie Knuckles had to take into account the sheer

[1] In January 1957: "Pop Art is: Popular (designed for a mass audience). Transient (short term solution). Expendable (easily forgotten). Low cost. Mass produced. Young (aimed at youth). Witty. Sexy. Gimmicky. Glamorous. Big Business."

1

physical space of the club: "It's a three-storey building, about 9,000 feet, and it sits in the western part of the Loop: the Loop in Chicago is the maindown area and the western part is more of an industrial, loft area. At that time (the early 80s) it was pretty desolate: it was the perfect place if anyone wanted to take a loft and build a nightclub." [2]

On arrival in the UK in 1986, this new sound demanded new venues: not poky basements, but great big barns like the Haçienda, an old yacht showroom and one of the earliest House strongholds. The sheer sound of House encouraged expansiveness - not a quality appreciated in these static, constricted islands: it very quickly fused (as did Rock'n'Roll with the Edwardians, way back in 1954) with a British youth style fantasy - the sun, sea, sex and drugs lifestyle experienced by thousands in Ibiza from the early 80s on.

In a now famous Transatlantic ellipse, Acid - a Chicagoan term for "burning", ripping off a sound: first amplified by Phuture's 303 epic, "Acid Tracks" (1987) - took on its 60s drug derivation as Ecstasy spread from the New York and London undergrounds, through Ibizia, to the heart of British youth culture. Instrumental in this shift - broadcast in the autumn of 1988 by D Mob's breakthrough hit, "We Call It Acieed" - was a club opened by Danny Rampling in late 1987: Shoom (plate 2). It was the organisers of Shoom who took a symbol still in use in Ibizia - where printers hadn't changed their imagery since the 70s - and unwittingly made it the brand logo of a new, nationally broadcast youth-cult, Acid House. The smiley badge originated in California sometime in the early 70s: as Cynthia Rose relates in *Design After Dark: the story of dancefloor style*, "Rampling specified the smiley face for his handouts, but (designer

George) Georgiou had the idea to show those smiley's tumbling down, like a cascade of then-popular pills." [3] It was this symbol that would be broadcast over the tabloid press, a couple of years later, as the symbol of Acid House.

Projecting from the sense of community and space inherent in the music, the new movement took on a drug derived, feelgood factor: even if you were stuck in Britain, you could make like you were in Ibizia (plate 3), where you could dance all night, where there was living and dancing room, where you were on permanent holiday. The whole story of the next few years can be seen in terms of this drive for more space: the slow increase in event size, the change of location from licensed clubs like the Haçienda, Shoom and Sheffield's Cuba to empty warehouses in forgotten quarters of the city, and ultimately into deep country. By autumn 1989, the national press was picking up on something that had been building in the two previous "Summers of Love"; the fact that people were travelling around the country in their thousands to dance all night - a situation that seemed like total anarchy. By 1990 these people had a name: ravers. [4]

A new culture demands new forms of communication. The handbill has been associated with pop since at least the 60s, when theatre chains would promote package tours with simple informational designs, printing black or red on a striking yellow background. In the late 60s, information about the music of the time, the San Franciscan rock boom, was disseminated by hand-drawn, lithographed posters, most of which were reduced to postcard size by the Family Dog and the Fillmore West (plate 4). In the early 70s, propaganda artists like Jamie Reid used cheap printing to publish provocative, political imagery - in a sequence of stickers, bills

[2] Interviewed by the author for the Channel 4 programme "Out On Tuesday" in January 1989.
[3] *Design after Dark*, pp 97-98 (Thames and Hudson, 1991).
[4] The term was first used in beatnik/Trad Jazz circles of the late 50s; reinterpreted for a new generation, it was popularised by journalists like Jack Barron (*NME*, late 1989-early 1990). In current use, it is as much an insult as anything else.

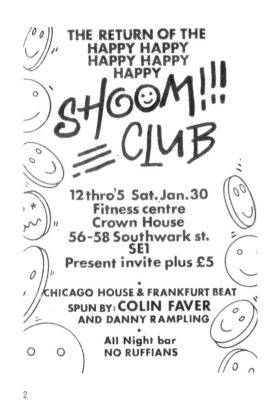

2

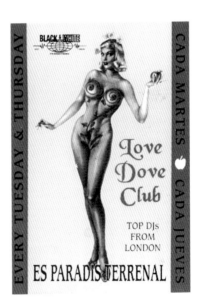

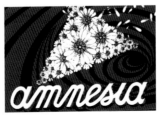

3

and illustrations for "Suburban Press".[5] Stimulated by the availability of the Xerox machine (from 1975 on), those associated with Punk produced an enormous variety of A4 images as the only way to publicise what was then a scandalous, taboo culture. (plates 5,6,7,8)

If 1988 is Year Zero, it's tempting to think of flyers as something completely new, but other roots can also be seen in the way that marketing skyrocketed during the 80s: anybody living in central London has had up to 20 coloured flyers, advertising anything from pizzas to industrial cleaning, pushed through their door every week. Although the music and the atmosphere of Acid was a 180 degree turn from the uptight club vibe of mid-decade, many of those involved in designing early flyers - like Trevor Johnson for the Haçienda's Nude or Hot (plate 9) - addressed the glossy, lavish textures of the style magazines which had dominated the early decade. Far from being a radical break with the early decade, most flyers took on the range of influences seen in *Design after Dark*: graffiti; skateboarding style; agitprop; 70s Retro; soundsystem theory; the London warehouse scene of the early 80s; the perennial attraction of collage.

The flyer may well be an advert, but - reflecting the make-up of rave culture at its height: split between the commercial and the illegal - it can also have a samizdat quality. Some of this has to do with their inherent speed: much of media politics has simply to do with who is faster - the national press, in their policing role, or the people trying to do what they want to do without being found out. Flyers are so cheap and so quick that they can broadcast information about illegal events before the authorities cotton on: you can see this most clearly in the rushed, crude graphics of the 1988 Kirby flyer, where the brand factor is supplied by the crudely

drawn smileys (plate 10). This changed quickly - as Harry of the DIY organisation says, "By 1992, the police had cottoned on" - but it established a context and an urgency for this form, the handbill or handout recast for a different time.

Whereas in the late 70s, the group was at the centre of activity, from the late 80s on, the club and DJ became the fount of graphic design. Flyer design has followed the changes in clubland since 1987: from the hermetic bulletins of the early underground days to the increased commercialisation that set in after 1989, when for many, numbers meant money; from hurriedly arranged warehouse parties to huge, licensed raves in sports centres, after 1990's Entertainment (Increased Penalties) Bill - sponsored by the Conservative MP for Luton South, Graham Bright - increased the fine for holding unlicensed events tenfold, allowed for the confiscation of assets, and introduced a custodial sentence (up to six months) as a penalty. Despite the attention of the judiciary, the police and the press, the underground party scene grew and grew, peaking with the five day, May 1992 Castle Moreton Festival (page 17), attended by up to 50,000 people, according to DIY's Harry, from "every kind of youth cult: ravers, travellers, Punks, goths, you name it".

Despite its mythology, Castle Moreton was out of control: stung by the sheer numbers of people, police and politicians enforced a draconian crackdown on the illegal scene - which, although effectively enforced since summer 1992, was finally enshrined by the Criminal Justice and Public Order Act of 1994. Once an uneasy fusion of the commercial and the underground, rave culture has become niche marketed to the nth degree - reflected in the myriad forms that have replaced the straight arrow

5 See *Up They Rise: the incomplete works of Jamie Reid* (Faber and Faber, 1987).

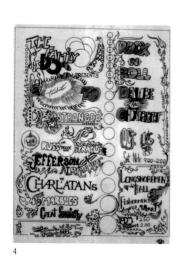

4

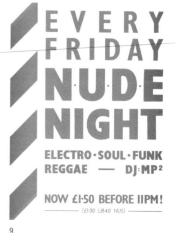

5

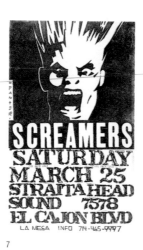

7

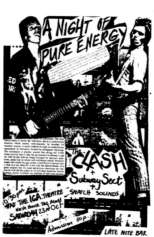

6

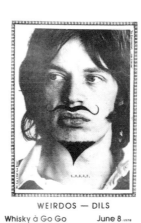

WEIRDOS — DILS

Whisky à Go Go June 8 1978

8

EVERY
FRIDAY
N.U.D.E
NIGHT
ELECTRO · SOUL · FUNK
REGGAE — DJ:MP²

NOW £1·50 BEFORE 11PM!
(£1·00 UB40 NUS)

9

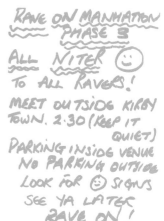

RAVE ON MANMATION
PHASE 3
ALL NITER ☺
TO ALL RAVERS!
MEET OUTSIDE KIRBY
TOWN. 2·30 (KEEP IT
 QUIET)
PARKING INSIDE VENUE
NO PARKING OUTSIDE
LOOK FOR ☺ SIGNS
SEE YA LATER
RAVE ON!

10

futurism of early Fingers Inc: Progressive House, Garage, Handbag, Hardbag, Ambient, Techno. The big fragmentation began in late 1991, with the onset of Hardcore - the relentless version of House that finally dispensed with its black roots. You can see the change from utopia into nightmare in the great flyer for Shrine (1991 plate 14): the jaw-clenching, nauseating paranoia of badly cut E elevated into a macho statement - not can you feel it, but can you take it?

If you had to put it in a basic equation, flyer design = drugs + computers. The early onset of Ecstasy - the chemical MDMA, which is related to both amphetamines and mescalin - unlocked a wave of euphoria that encompassed the ability to dance fast for hours, a heightened sexuality, some visual hallucinations, and, further, a cosmic sense of well-being with the universe and fellow humans. This was not one, but two, maybe three "Summers of Love" to match that of 1967, so fetishised by babyboomers. Early flyers like Blastoff Into Orbit (plate 13), encapsulate this lift-off into a new psychedelia, while a pivotal sequence of flyers for Spectrum (1988 plate 11) faithfully updates the palindromic Rick Griffin eyeball (plate 12) that marks one furthest outreach of late 60s design. In this, 60s Acid, LSD, made a comeback - adding the psych and Pop Art of blotter design into the House mix.

Drug-based movements always go through the Icarus trajectory: anticipation, flight, over-reaching, the crash. From the first publicised death from Ecstasy, Claire Leighton at the Haçienda in July 1989, there have been at least fifty other deaths attributable to the drug's effects: most notably due to heat exhaustion and heart failure in a club environment. Other problems have been caused by the sheer volume of the market:

according to the Home Office, Ecstasy seizures rocketed from 44,000 tablets in 1990 to 365,000 in 1991. The temptation to cut a capsule or a pill with other compounds - ranging from amphetamine to strychnine to ketamine - was too much for the illegal economy: together with the law of declining returns in E use - you need more to get back to the original blast-off - the resulting toxicity can be seen in the regular advice features run by the dance press, or in the flyer-derived packs put out by Manchester's Lifeline (the Peanut Pete cartoon) or in the "Chill Out - A Raver's Guide" pack produced by the Merseyside Drug Training and Information Centre.

That primal rush, however, is still the hook for the massive industry that rave has become: you can still see myriad variations on a fantasy utopia in the names of nights like Dreamscape, Inner Sense, Beyond Therapy, Enlightenment, all the way to Eclipse and Entropy. Here, drug-induced transcendence is part of the marketing strategy: the designs range from the one-off, airbrushed painting - like Pez for Telepathy (1992) to the crude Dali scannings of Eclipse. This dovetailing of marketing with design can be seen in a flyer like Junior Tomlin's Raveworld (1992 plate 15), with its synthetic, chilling set of masks and heads lost in space. The full disjunction between marketing and reality can be seen in the flyer for Milk and Honey (1995): the exterior shows a pyramid and the cross of Ankh, the interior claims "a tomb" and "a harem", but The New Kingdom lies in deepest....Walsall (plate 18).

What Xerox was to Punk, the Mac is to the flyer. Pez: "Although all my pieces are airbrush illustrated, I try to make each look as computer-generated as possible, because the market out there is a computer

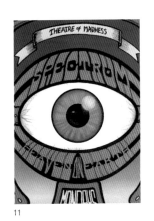

11

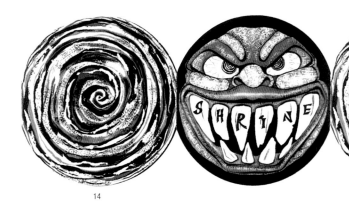

14

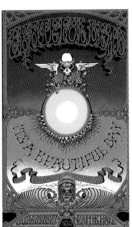

12

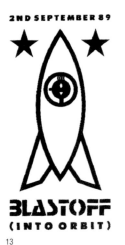

13

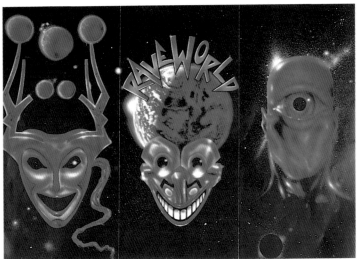

15

market." The flyer era has spanned the phasing-in of the Apple Mac as an accepted graphic design tool: most immediately, you can pull in images from anywhere with the scanner, and within minutes enhance and stretch them. As Ian Anderson of The Designers Republic explains: "On-screen you can draw, you can cut, you can scalpel, you can create layers of intensity that would be impossible physically. If you do something you don't like, you can start again. You can explore a lot of ideas a lot quicker. The Mac gives control and the ability to create something that looks professional but a lot cheaper."

This is the Mac as a gigantic collage machine. Just like the pop video - the promotional form of the mid- to late 80s - the flyer minces up images from pop's past, from the history of art, from any source in a whirligig, millenial dance. It's possible to trace a history of flyers in Helen Storey's Club Scene column in *DJ Magazine* - tagline: "To some it's a useful list, to others it's a way of life" - which from 1991 on has charted clubland in a mixture of information bulletin and visual showcase. "I always thought flyers very interesting," she now says; "It was good to show them as opposed to pictures of people with massive pupils, looking really off it. Although flyers have become part of big money since 1989, I wanted to put in stuff that people did with Letraset, or people who were doing something a bit different."

Through this record, and the research done by Phil Beddard at 3 Beat Music, Mike Dorrian at Nonconform and Brian Parkes, it's possible to outline the following, by no means definitive guide to flyer trends.
1. Utopia/Dystopia - see the design for the Birmingham club of the same name on page 62 - these may take the form of original artwork - like Pez's airbrushed pictures, which hark back to the designs of Michael English and the 70s fantasist Boris Vallejo (Tootie Frootie, 1992 plate 16); images derived from computer games (The Edge, 1992; Amnesia House, 1992; Paradox, 1993); simple travelogues (Rimini comes to Icon, 1993); and the pure rebirth/dawn of a new era approach (Time Out, 1990). 2. Fractals (Energy, 1990; Passion, 1991; Joy for Life, 1994) and close-up flowers: the orchids used by Deep and Devastating (1993). 3. Spilling into sourced psychedelia, like the adaptation of Richard Avedon's famous 1968 poster of George Harrison (Desire, 1992 plate 17; Club Labyrinth, 1993), or the famed cover of the Beatles' "Abbey Road" (Helter Skelter, 1993); 4. Sex: this comes partly from the impetus given by gay clubland - the Haçienda's Flesh, Heaven's Ciao Baby and Fruit Machine, Bingo at Paradise Factory, After Hours ("Hardened Homos get fucked", 1994), even a rip-off from queer art terrorists Homocult (Fantasy Ashtray, 1994) - and partly from the most basic effect of E: see the prolonged campaign by Wobble (1993-1995, club logo as phallic symbol, plate 19). Since 1992 - Helen Storey, "There was a picture of Naomi Campbell falling over; everybody used that one" - there has been a rash of "babes" in various stages of undress, ranging from supermodels through standard nudie shots (lurid: Body Heat, 1991; tacky: Centrefold, 1995 plate 22, stylish: Bubblicious, 1993) to pictures of cattle fucking (Grind, 1994) - reminiscent of *Oz* in its heyday; note the abstracted, archetypal machismo of Jungle flyers, all Greek Gods, cocks and lions; note also the phallic icon (Immense, 1991). My final word on this is the parody House rap taken from a flyer for CUM II (1992 plate 21): "In the beginning there was cum and such was the joy that it gave that our disciples are ready to CUM AGAIN...are you?"; 5. Punk: sourced

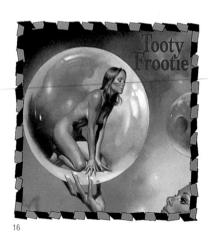
16

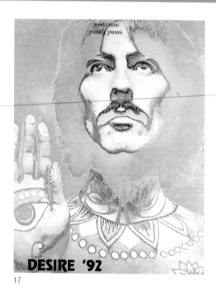
DESIRE '92
17

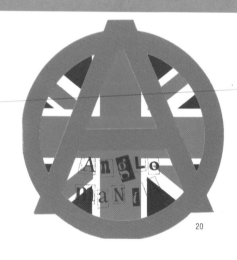
20

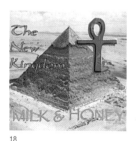
18

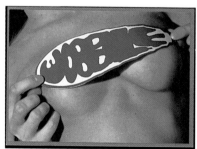
19

DYKES & QUEERS
BEHOLD
THE SECOND CUM
IS UPON US!
21

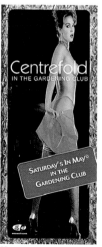
22

as a (negative) national symbol (Anglo Mania at Pushca, 1993 plate 20), and a youth-cult archetype with great graphics - from parodies of Jamie Reid's cover for "Never Mind The Bollocks" (Menace, 1992; Venus, 1990) through Dada-style montages (Sensured, Los Angeles 1991; the Contrive Club, 1994) - to the creative update provided by Back to Basics, who have licensed Reid's original designs with the co-operation and collaboration of the artist. (plate 23) 6. More high-70s Retro includes: "Saturday Night Fever" (Sesame Street Fever at Stringfellows, 1992; Fever at Oz, 1995), parodies of Roxy Music's "For Your Pleasure" and "Country Life" LP covers (Street Life, 1995) and "A Clockwork Orange" (Love Ranch, 1991page 130); for an abstraction of this aesthetic, see the stylised Afros of Pimp (1994 plate 24); 7. Sundry high art and design rip-offs: the Warhol banana (Yellow, 1993), Salvador Dali (passim, but especially Eclipse), Fornasetti (Puscha, 1992). 8. Icons: whether Clint Eastwood (Revenge 6, 1990), William Burroughs (The Big Chill, 1994), Che Guevara (Golden, 1993), a naked Batman (Aurora, 1992), Steve McQueen (Escape, 1995), Queen Elizabeth II (for a mixed night at Nation, 1993 plate 25) or the BBC2 Testcard girl (Heaven, Liverpool 1991 page 128); 9. Cut-out shapes, whether rockets (The Crazy Club, 1991); cartoon rhinoceri (Horny, 1994); condoms (Icon Cert-X, 1992 plate 26); a lightning flash (Paradise, 1993); a skull and crossbones (The Pirate Club, 1993 plate 30); leaves (Modesty, 1995); champagne in an icebucket (MARS, 1994 plate 27; Greek Gods + champagne = junglist) and, of course CD-sized circles (The Orbit, 1991-1994; Wildlife, 1994); 10. 3-D items like: a washing-up glove with a pink feather (Housewives Choice at Pushca, 1994 page 145); an orange fun fur squeaky toy (Hullaballoo, 1995 plate 29; a Chinese mint sweet (Eat

Me, 1986 page 131); a message in a tiny bottle with sand (Strictly Fish, 1995). 11. Logo parody: quite possibly showing the penetration of the corporate aesthetic into our dreams, but just as likely a bit of cheek; this is endemic, but a few examples include Wrigley's Spearmint (Tuskers, 1993), the Royal Mint (the £5 note detourned by the Zap club, 1991); *Vogue* magazine (Vague at Hi-Flyers, 1995); Tampax (Jampax, 1991); Daz (Quest, 1993); m&m's (Virgo, 1995 plate 28), Burberry (Euro Dance, 1991); Brillo (051, 1991) or, the best, Rizla (Rava, 1991) and Chanel (Girls on Top, 1993); this spills into: 12. Club logos: initiated out of the early 80s style boom by the Haçienda, but industrialised after 1992 - when raves went out of the fields and into the clubs - by the Ministry of Sound: a whole marketing brand name. Other club logo series have been undertaken by organisations like the 051 (1992); Cream (1993-1995), Megadog (1992-1995 - a return to the black and white, Xerox certainties of Punk). There also have been themed image series: 30s and 40s Hollywood English archetypes, for example, Charles Laughton as Henry V (Love Ranch: Merry England, 1993 plate 32); a series of 24 mocked up cowboy cigarette cards (Penetration Nation, 1993 plate 31); snapshots of punters (Cream, and parodically, Smile, 1993 plates 33 and 34); celebrity grotesquerie (The Ministry of Sound, 1994 , starring Mrs Thatcher with bared breasts page 123) and finally, 13. Paganism: from Energy's 1991 illustration of Stonehenge (plate 36), to the flying cows of Hyperbolic - A Summer Madness, (1994 plate 35).[6]

The high flyer reveals the perennial contradiction of pop culture: between innocence and experience (drugs versus the inner child), between hope

[6] For an early "serious and intellectual Late Show stylee" look at flyer imagery, see Damian Harris: "I'm Handy Fly Me!", *DJ Magazine*, January 1992.

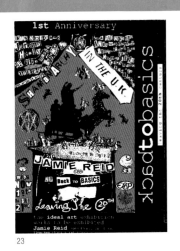

23

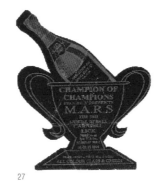

27

29

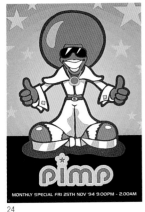

24

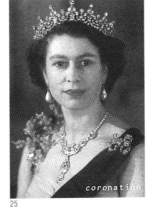

25

28

30

26

and cynicism, between spirituality and free market economics. There is a contradiction that the flyer has to itself, however: between a persistent, tacky futurism and a strong pagan influence, between virtual and real space. Again and again, you see the sun (Dreamscape, 1992) or read the words, "A Midsummer Night's Dream" - that time of year when energy is at its peak and reason flies over the moon: it is no accident that the Government has zeroed in on "a succession of repetitive beats" as the index of rave music in clause 63b of the Criminal Justice and Public Order Act of 1994. Here is the pagan call, for all to hear.

Looking at the near kitsch flyer for 1991's Sunrise (plate 37), you're not sure whether it represents the dawn of a new age or is a harbinger of disturbance. In this, the virtual/real space occupied by the flyer gives existential authority to its implicit claim to be the intuitive record of now, that time when the old order is breaking up and the millenium deadline looms. Intuition fights reason, reason fights barbarism, paganism fights religion. We are both fearful and excited by this well-advertised deadline for a future which is delicately poised between dream and nightmare: this range of possibilities has already been rehearsed by the transient, flashing images from the subconscious collected here.

PLATES: **1** Progress 1994 The Wherehouse Derby. **2** Shoom 1989 Crown House London. Designed by George Georgiou. **3** Amnesia Ibizia and Love Dove Club 1992 Ibizia. **4** The Seed 1965 Designed by George Humar and Michael Ferguson. **5** The Roxy Club 1970 London. **6** The Clash 1976 ICA Theatre London. Designed by Sebastian Conran. **7** Screamers 1978 El Cajon Blvd La Mesa. Designed by Gary Panter. **8** Weirdos - Dils 1978 Whisky a Go Go Hollywood. Designed by Duh Champ. **9** Nude 1989 The Haçienda Manchester. Designed by Johnson Panas. **10** Rave On Manhattan 1988 Liverpool **11** Spectrum 1989 Heaven London. **12** Grateful Dead; It's a Beautiful Day 1969. Designed by Rick Griffin. **13** Blast off 1989 London. **14** Shrine 1991 The Eclipse Coventry (unfolded). **15** Raveworld 1992 140 Nathan Way London. Designed by Junior Tomlin (unfolded). **16** Tootie Frootie Shellys Stoke-on-Trent. **17** Desire 92 Tascoe Warehouse London. Designed by Pez. **18** Milk & Honey 1995 New Kingdom Walsall. **19** Wobble 1994 Branstons Venue Birmingham. Designed by Phil Gifford. **20** Anglo Mania 1994. London. Designed by Pushca. **21** CUM 2 1992 Merseyside Academy. **22** Centrefold 1995 The Gardening Club London. **23** Back to Basics 1994 The Music Factory Leeds. Concept by Jamie Reid. Designed by SquarePeg:Design **24** Pimp 1994 Palomas Wolverhampton. Designed by SquarePeg:Design. **25** Nation 1993 Merseyside Academy Liverpool. Designed by Shed. **26** Cert X 1993 051 Liverpool. Designed by Sawnoff Productions. **27** MARS 1994 Abbott Street London. **28** m&ms 1995 The Virgo Amsterdam. **29** Hullabaloo 1995 All Nations Club London. **30** The Pirate Club 1993 The Rocket London. **31** Penetration at Nation 1993 Merseyside Academy Liverpool. Designed by John Whitworth and Daniel Syrett. **32** Merry England 1993 Cafe de Paris London. **33** Cream 1993 Merseyside Academy Liverpool. Designed by Shed Photography by Jonathan Keenan. **34** Smile 1993 Merseyside Academy Liverpool. Designed by Ian Photography by Mark McNulty. **35** Hyperbolic 1994 Speedway Stadium Kings Lynn. Designed by ADG. **36** Energy 1991 The Eclipse Coventry. **37** Sunrise: A Midsummer Nights Dream 1991 London.

31

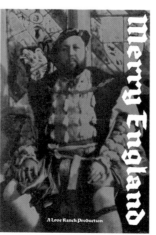
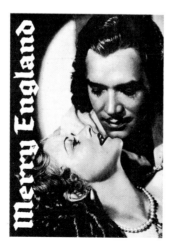
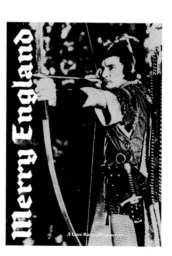
32

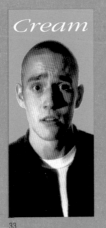
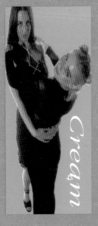
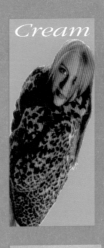

The People flyer. The plot was, both Darren Hughes and I felt that the people were the most important factor of any successful club. So we decided to rope in a photographer and shoot a load of our punters to put on the front of the flyers. I loved this idea, it was brilliant until another promoter didn't like the way we were presenting our club. He and a few of his pals made a mockery of our flyers by posing on their version looking like tits. Well the row which took place went on for weeks, it even ended up as an article in *The Face*, "Club Wars" or something like that.

James Barton Cream **170895**

33

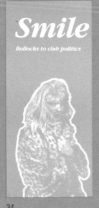
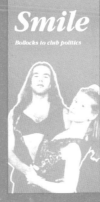
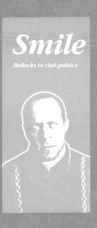

34

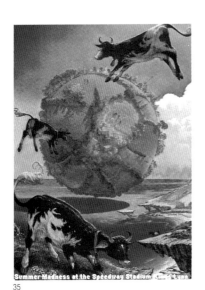

Summer Madness at the Speedway Stadium King's Lynn

35

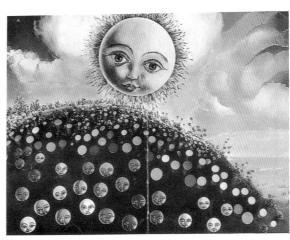

on *MIDSUMMER NIGHT,* SAT 24th JUNE
THE MOST SPECTACULAR EVER

Supernatural
Suspense
SUNRISE
Magical
Mystery

10pm - 10am, 12 Hours of midsummer magic

TURNTABLE WIZARDS

EDDIE RICHARDS • JUDGE JULES
TREVOR FUNG • PAUL ANDERSON
FRANKIE VALDINE • FABIO

MUSICAL MAGICIANS

LIVE P.A. : RAM JAC
MASTER of CEREMONIES: Mr C
Gordon & the Magic Trumpet

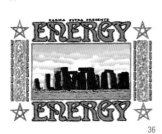

36

37

Wild and Peaceful
Date. 1988
Site. Africa Centre.
London
7" flexidisc

- F R I D A Y ¡YAGIЯꟻ -

62—68 Rosebery Avenue, London, EC1 ═══ "EMERGENCY"

JUNE 24 ⅂⅄ ƎИU⅃

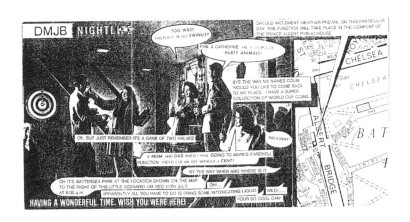

Emergency
Date. 1986
Site. 62-68 Rosebery Avenue.
London

DMJB Nightlife
Date. 1986
Site. Anhalt Road.
London

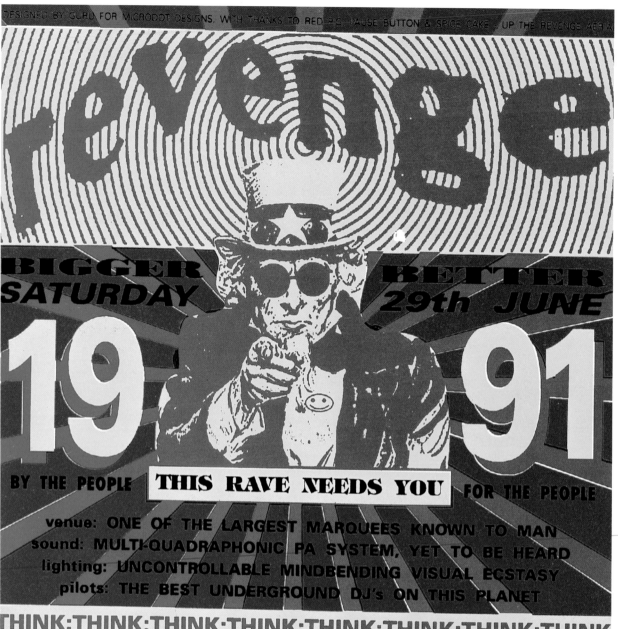

revenge

BIGGER
SATURDAY
29th JUNE
BETTER

19

91

BY THE PEOPLE
THIS RAVE NEEDS YOU
FOR THE PEOPLE

venue: ONE OF THE LARGEST MARQUEES KNOWN TO MAN
sound: MULTI-QUADRAPHONIC PA SYSTEM, YET TO BE HEARD
lighting: UNCONTROLLABLE MINDBENDING VISUAL ECSTASY
pilots: THE BEST UNDERGROUND DJ's ON THIS PLANET

THINK:THINK:THINK:THINK:THINK:THINK:THINK:THINK

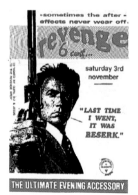

»sometimes the after-
effects never wear off.

revenge

saturday 3rd
november

"LAST TIME
I WENT,
IT WAS
BESERK."

THE ULTIMATE EVENING ACCESSORY

Revenge
Design. Guru for Microdot Designs
Date. 1991
Site. Wigan

rhythm religion

kool kat . thursday 28th june . £1.50/£2.50

house . hip hop . visual fx from sirius

DiY '90

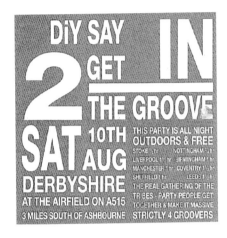

DiY SAY
GET **IN**
2 THE **GROOVE**
SAT 10TH
AUG
DERBYSHIRE
AT THE AIRFIELD ON A515
3 MILES SOUTH OF ASHBOURNE

THIS PARTY IS ALL NIGHT
OUTDOORS & FREE
STOKE ½ hr NOTTINGHAM ½ hr
LIVERPOOL 1 hr BIRMINGHAM 1 hr
MANCHESTER 1 hr COVENTRY 1 hr
SHEFFIELD 1 hr LEEDS 1 hr
THE REAL GATHERING OF THE
TRIBES - PARTY PEOPLE GET
TOGETHER & MAKE IT MASSIVE
STRICTLY 4 GROOVERS

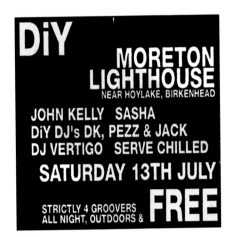

DiY
MORETON
LIGHTHOUSE
NEAR HOYLAKE, BIRKENHEAD
JOHN KELLY SASHA
DiY DJ's DK, PEZZ & JACK
DJ VERTIGO SERVE CHILLED
SATURDAY 13TH JULY
STRICTLY 4 GROOVERS
ALL NIGHT, OUTDOORS & **FREE**

DIY
Rhythm Religion
Date. 1990
Site. Kool Kat.
Nottingham

Get In 2 The Groove
Design. Rick Down
Date. 1992
Site. The Airfield.
Derbyshire

Free Party
Design. Rick Down
Date. 1992
Site. Moreton Lighthouse.
Liverpool

Rhythm Collision 2
Design. Rick Down
Date. 1990
Site. The Green Club.
Nottingham

Datura meteloides
Design. Rick Down
Date. 1990
Site. Marcus Garvey Centre.
Nottingham

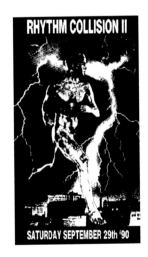

RHYTHM COLLISION II

SATURDAY SEPTEMBER 29th '90

Datura meteloides
"And it was best taken in the company of a good singer, for a strong and expressive voice was believed to be capable of controlling it's power."

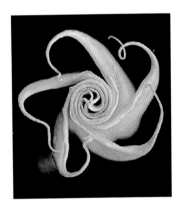

DIY: a simple idea - do it yourself, an extension of the punk ethic into the House movement at a time when the glorious revolution of 1988-1989 was beginning to die beneath bankrupt raves and a zeitgeist that was to produce Hardcore. The synergy of urban DJs and sound systems and the almost endemic love of illegality amongst a travelling scene which had effectively imploded, ushered in a new revolution, a cross cultural attempt to keep the spirit of the "Summers of Love" alive and kicking. This continuity of a vision exploded across the south of England between 1990 and the summer of 1991 and culminated, via innumerable small parties in fields, warehouses and even building sites, in the gargantuan Castle Moreton Festival in May 1992. Simultaneously, the mainstream movement was, as seems almost inevitable, labelled "rave", packaged, diluted and re-sold. This book concerns flyers, included are some early DIY free party flyers from a more innocent time when our name could be added to such flyers without fear of serious prosecution. Castle Moreton, where we played for five continuous days, gathered 50,000 young people from every conceivable sub-culture, in one place *with no publicity*, was what finally took this scene into the mainstream consciousness and lead directly to the horrors of the Criminal Justice Act. We now find ourselves in the lull which follows any revolution, many systems are still out there doing the business and using the ideas which were fermented in those early days and which have deeply affected much current culture, but without having ever been properly documented. Hopefully this book will redress some of that inbalance.

Harry DIY **030895**

FEATURING DJ'S TREVOR FUNG, FARLEY, ...GUEST DJ'S..., ROCKY & DIESEL,,,AT FULHAM FILM
STUDIOS, 101 FARM LANE, SW6, Tickets from BOY (King's Rd.), RED OR DEAD (Neal & Berwick St,)
BLACK MARKET (D'Arblay St.) & GARBO'S HAIRDRESSERS (The Grove, Ealing).

NEW BEAT ♥ DEEP HOUSE ♥ TECHNO

S♥LSTICE DANCE

GET REAL COME CLEAN HUGS NOT DRUGS

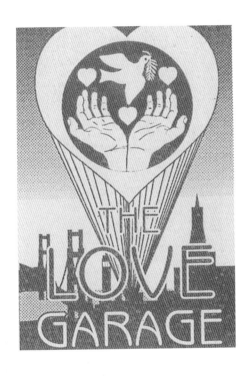

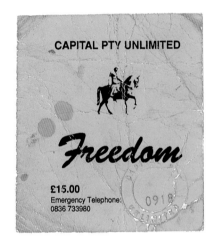

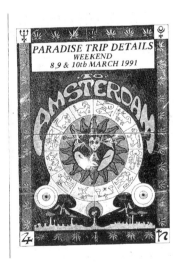

Balearic
Date. 1988
Site. Fulham Film Studios.
London
opposite

Solstice
Date. 1988
Site. Africa Centre.
London

The Love Garage
Date. 1993
Site. 147 King Street.
San Francisco

Freedom
Information line

Paradise Trip to Amsterdam
Date. 1991
Site. Amsterdam

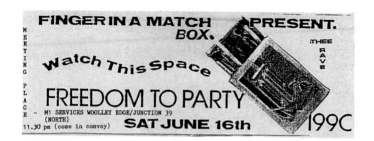

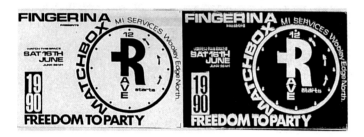

Freedom To Party
Date. 1990
Site. M1 Services.
Woolley Edge

Acid
Date. 1988
Site. Centre. Slough

Flyers and club culture have always gone hand in hand. I
first noticed them during the 80s warehouse parties like
Circus Circus Circus, the Dirtbox etc. then Acid House.
The evolution of flyers during Acid House was interesting.
Some of the best clubs had the cheapest bits of
photocopied tat or no flyers at all since they didn't need to
advertise. As the interest in Acid grew the flyers seemed
to as well - you would grow wary of the A4 double-sided
full-colour flyer with some dodgy poem at the top. After a
while and a few sad nights out these kind of flyers, plus
any mention of Bouncy Castles only meant dodgy
criminals to me.

Richard Norris The Grid **250795**

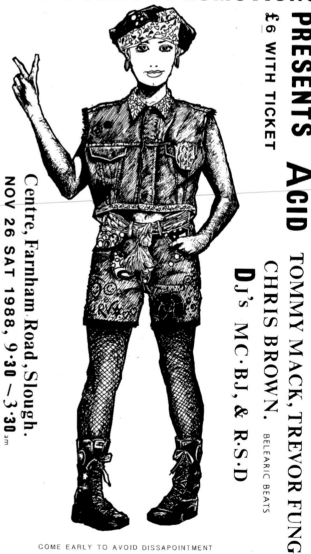

DENIM PARTY PROMOTIONS

PRESENTS ACID

£6 WITH TICKET

TOMMY MACK, TREVOR FUNG
CHRIS BROWN.
DJ's MC·BJ, & R·S·D
BELEARIC BEATS

Centre, Farnham Road, Slough.
NOV 26 SAT 1988, 9·30 – 3·30 am

COME EARLY TO AVOID DISSAPOINTMENT

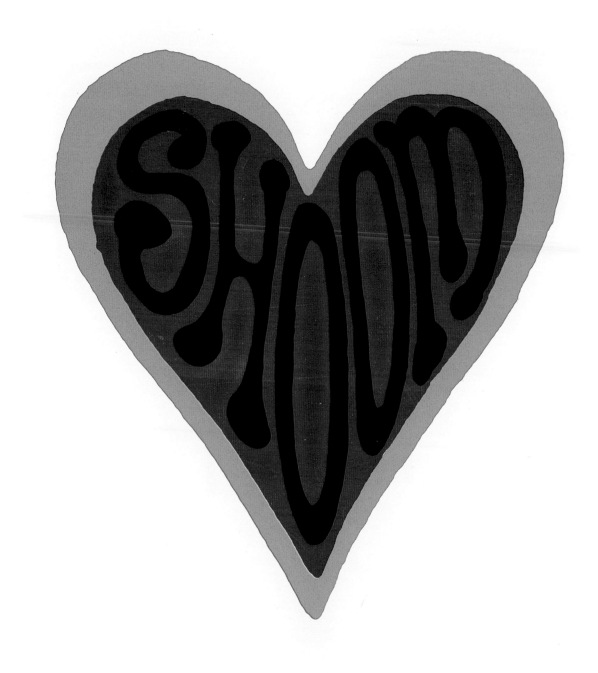

Shoom
Design. B. Reid
Date. 1988
Site. Busbys. London

The Shoom flyers really represented perfectly the moment and personality
of the club. There was a real explosion in the Acid House scene then and
the flyer summed up the positive side of it. I don't think promoters
nowadays have enough art appreciation - there are too many flyers with
just type set on them. Flyers represent the personality of a club and the
promoters who realise the importance of art usually end up with better
flyers - and better clubs.

Danny Rampling Shoom **230895**

Easter Rave
Design. Thunder Jockeys
Date. 1991
Site. The Brain.
London

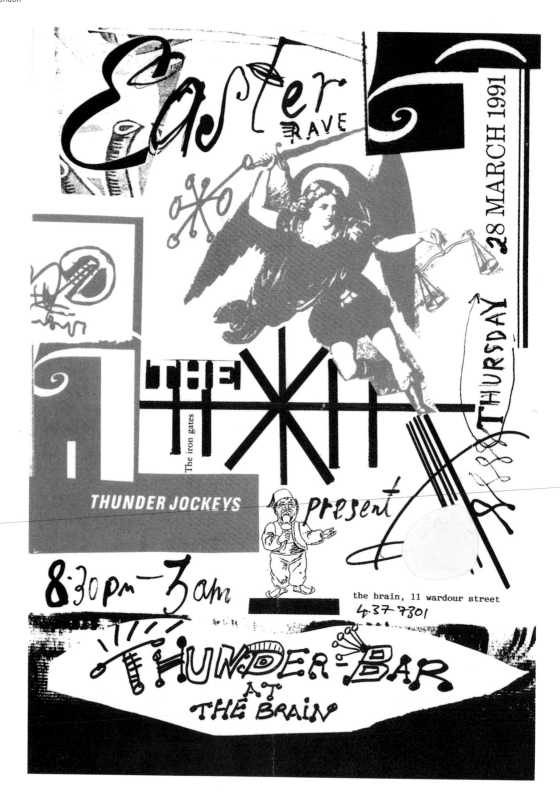

JAM · RAVE · PARTY · DIAL

08 364 01 374

RAVE PARTY

DIAL
CLUB HOTLINE

CHARGED AT 38p INC VAT PEAK & 25p INC VAT PER MIN OFF PEAK

The best ideas often come about due to tight or nonexistant budgets. It's a great opportunity for designers and artists to rise to the challenge and get their work seen at the same time. After all, even a small club is going to do a print run of at least 5,000 flyers. That's 5,000 people seeing your work. You'd be doing well to get that many in a gallery.

George Georgiou **290895**

Wag It
Date. 1989
Site. Wildside.
London
back

Shoom
Design. George Georgiou
Date. 1985
Site. Crown House.
London

HAPPY HAPPY
HAPPY HAPPY
HAPPY
SHOOM!!!
= CLUB

TRANCE
DANCE

12 THRO' 5 SAT. FEB. 13
FITNESS CENTRE, CROWN HOUSE
56 - 58 SOUTHWARK ST. SE1
PRESENT INVITE PLUS £5
·HEAVY HOUSE SPUN BY·
COLIN FAVER
DANNY ☺ RAMPLING
• NO RUFFIANS

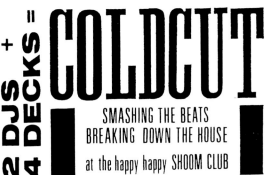

2 DJS +
4 DECKS =
COLDCUT
SMASHING THE BEATS
BREAKING DOWN THE HOUSE
at the happy happy SHOOM CLUB

Deep House & Alternative spun by
DANNY RAMPLING &
STEVE PROCTOR
FEB. 27-12 THRU 5
Present invite plus £5
1ST FITNESS CENTRE CROWNE HOUSE
56 58 SOUTHWARK ST SE1
NO RUFFIANS

promotions presents

FROM NYC U*S*A

FRANKIE BONES

+ANDY CARROLL, JAMES

QUADRANT PARK
BOOTLE LIVER·POOL

THURS 20TH SEPT 1990

ADMISSION £4.00

Quadrant Park
Design. James Barton
Date. 1990
Site. Quadrant Park.
Liverpool

Everyone was dancing on the bars. There were people everywhere. It was the first time I heard foghorns in a nightclub. It was the same kind of atmosphere as a world championship boxing fight. When someone dropped a record it was like taking a penalty at Wembley...you couldn't hear the music for the screaming. It was quite scary.

John Kelly *Muzik* **100895**

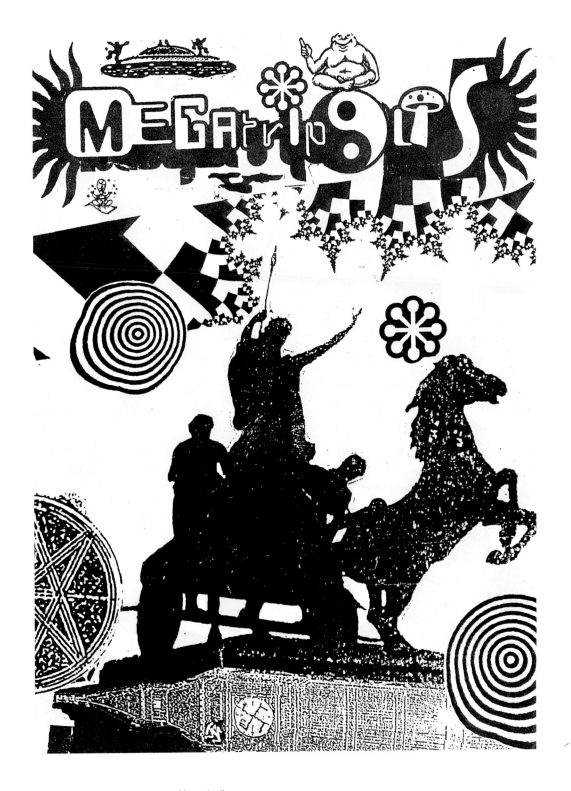

Megatripolis
Design. Jamie Reid
Date. 1994
Site. Heaven, London

As a multi-media artist having interacted with sound, music and dance, particularly in "popular culture", involving my work in the rave scene was a natural progression for me. It is where the most vibrant and radical art is happening, having much more relevance as art for the people than the established and elitist fine art gallery circuit which is woefully out of touch and exclusive.

Jamie Reid **150695**

IT'S BACK & IT'S BARKING!!!!

CLUB DOG

ALL NIGHT DOG PARTY
FRIDAY 14TH JAN
AUTECHRE
TIMESHARD
THE CORRIDOR
LULL

MICHAEL DOG
MR. BECKER
PHIDGET EVOLUTION

9 pm - 6 am £5 / £4 concs
AT THE ROBEY SEVEN SISTERS RD FINSBURY PK N4

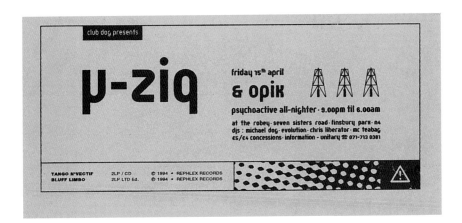

Everyone uses any catchy images they can find to stick on their flyers. Because the concept of creative flyers has become *de rigeur*, an interesting flyer no longer means that the club will be good. It's almost the opposite these days. The more glitzy and expensive the flyer looks, the more likely the club is to be either boring, elitist or otherwise totally uncreative.

Michael Dog **030795**

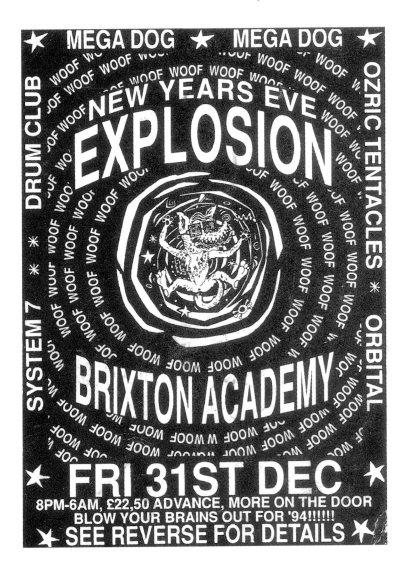

Club Dog
Design. Bob and Michael Dog
Date. 1994
Site. The Robey.
London

Muziq
Design. Bob and Michael Dog
Date. 1994
Site. The Robey.
London

Mega Dog
Design. Bob and Michael Dog
Date. 1994
Site. Brixton Academy.
London

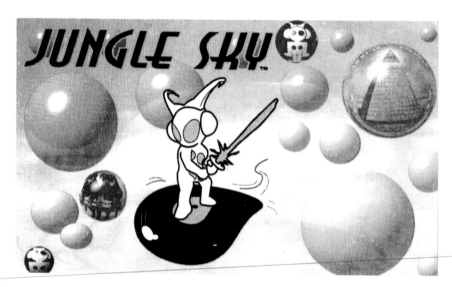

The Language Lab
Date. 1989
Site. The Palace.
London

Jungle Sky
Design. Liquid Sky
Date. 1994
Site. The Cooler.
New York

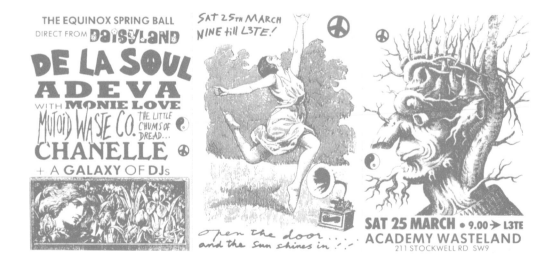

Metamorphosis 3
Date. 1989
Site. Academy Wasteland.
London
unfolded

The Last of the Summer Wine
Date. 1992
Site. Engine House.
Birmingham

EXTRAS REQUIRED FOR

THE LAST
OF THE
SUMMER WINE

FEATURING AN ALL-STAR CAST OF

DANNY RAMPLING ☆ GRAHAM PARKES
JOHN KELLY ☆ LEE FISHER
MATT BOOKER ☆ STEVE BIGNELL
AND MARK 'TYGER' HUGHES

PRODUCED AND DIRECTED BY

FULL OF BEANS
VARIETY
&
D.CADENCE

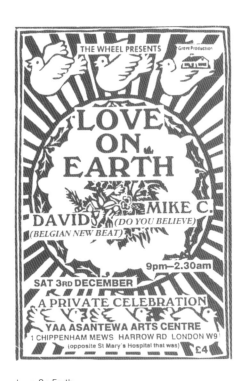

Love On Earth
Date. 1989
Site. Yaa Asantewa Arts Centre.
London

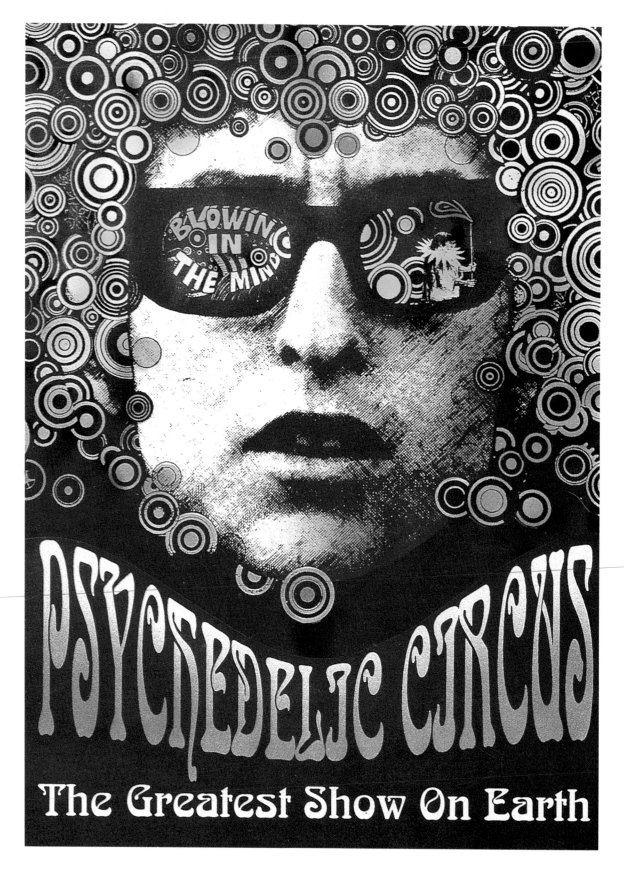

Psychedelic Circus
Date. 1993
Site. Bagley's.
London

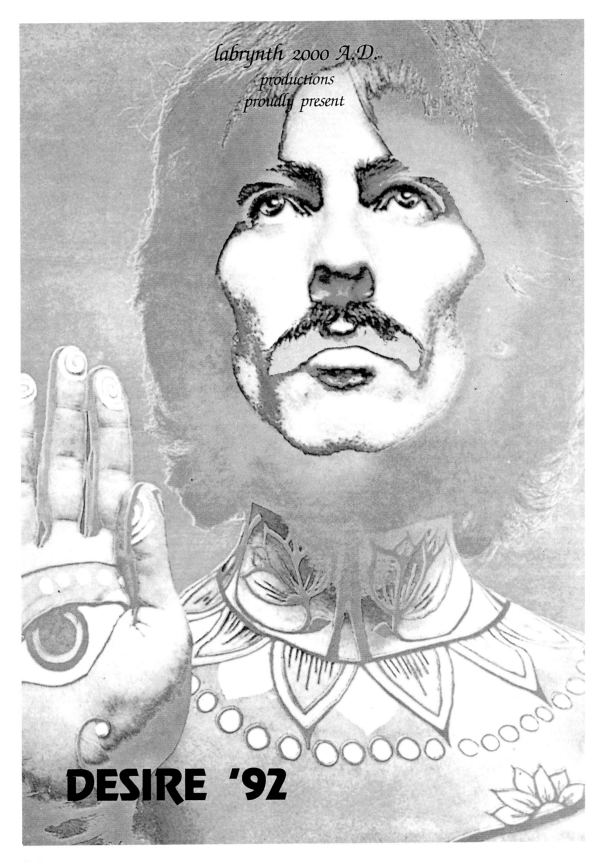

labrynth 2000 A.D.
productions
proudly present

DESIRE '92

Desire
Design. Pez
Date. 1992
Site. Tascoe Warehouse.
London

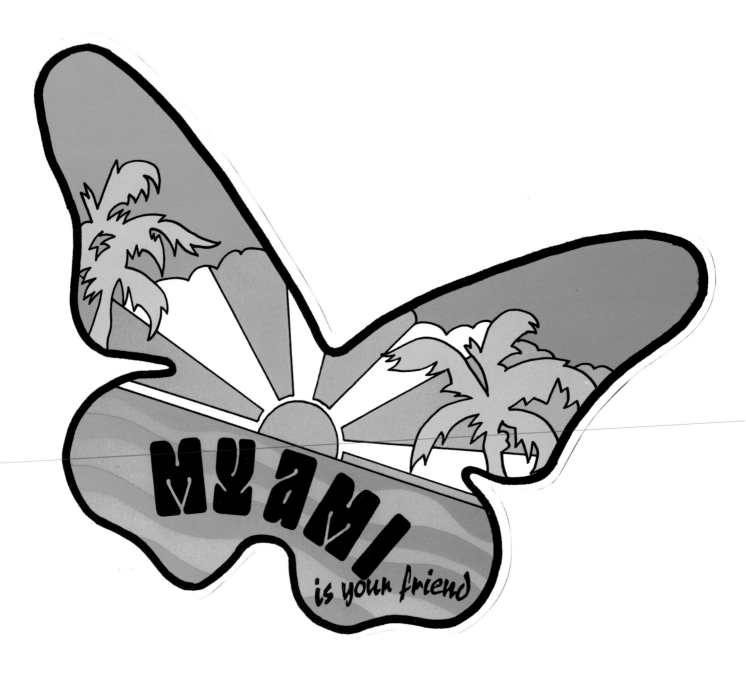

Myami
Date. 1988
Site. 2-3 Burlington Street.
London

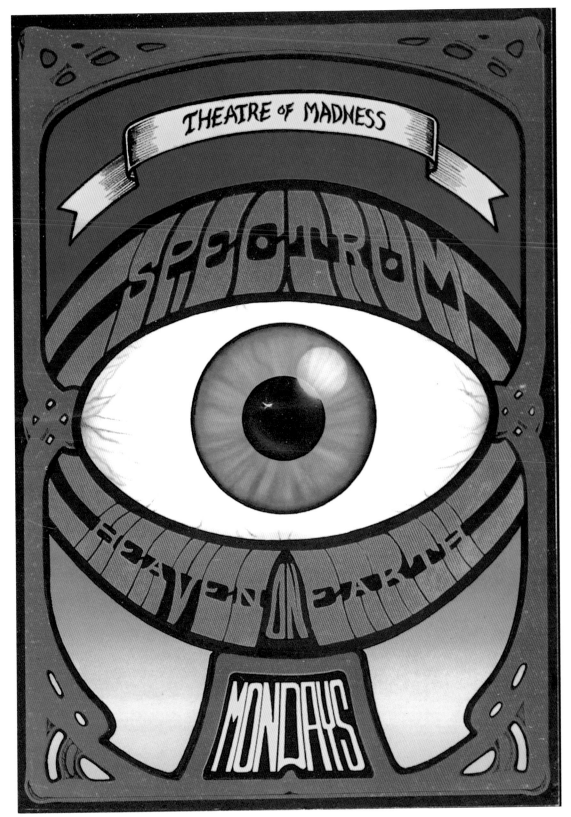

Spectrum
Date. 1989
Site. Heaven.
London

The Spectrum flyers are the most memorable because they really summed up the whole Acid House scene. The image went on t-shirts and ended up being sold world-wide. It even ended up being exhibited at the Victoria and Albert Museum in London which is an amazing feat.

Paul Oakenfold **260795**

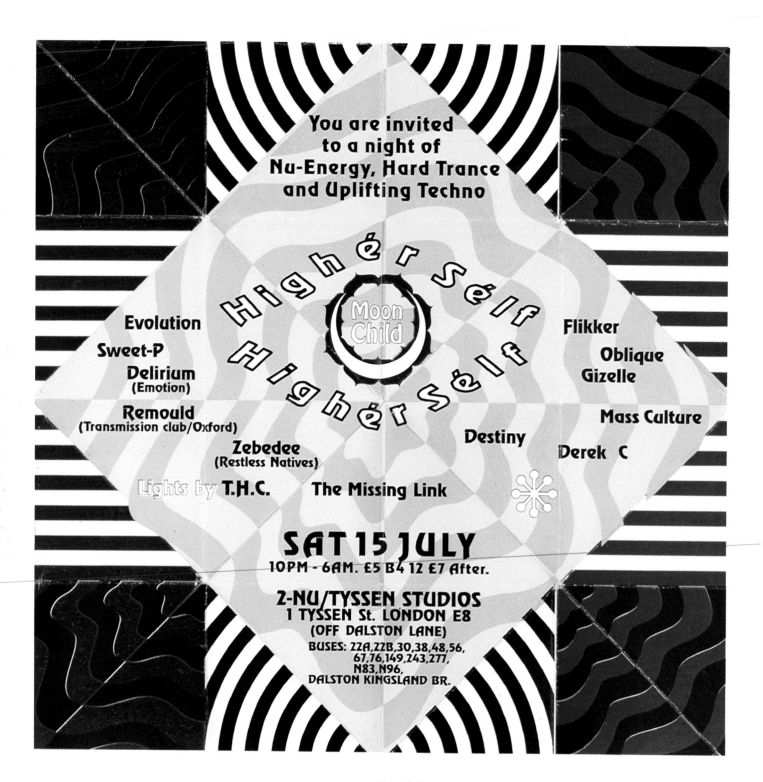

You are invited
to a night of
Nu-Energy, Hard Trance
and Uplifting Techno

Higher Self
Higher Self

Moon Child

Evolution
Sweet-P
Delirium
(Emotion)
Remould
(Transmission club/Oxford)
Zebedee
(Restless Natives)

Lights by T.H.C. The Missing Link

Flikker
Oblique
Gizelle

Mass Culture

Destiny
Derek C

SAT 15 JULY
10PM - 6AM. £5 B4 12 £7 After.

2-NU/TYSSEN STUDIOS
1 TYSSEN St. LONDON E8
(OFF DALSTON LANE)
BUSES: 22A,22B,30,38,48,56,
67,76,149,243,277,
N83,N96,
DALSTON KINGSLAND BR.

Higher Self
Date. 1995
Site. 2-Nu/Tyssen Studio.
London
unfolded, supplied
with handy plastic bag

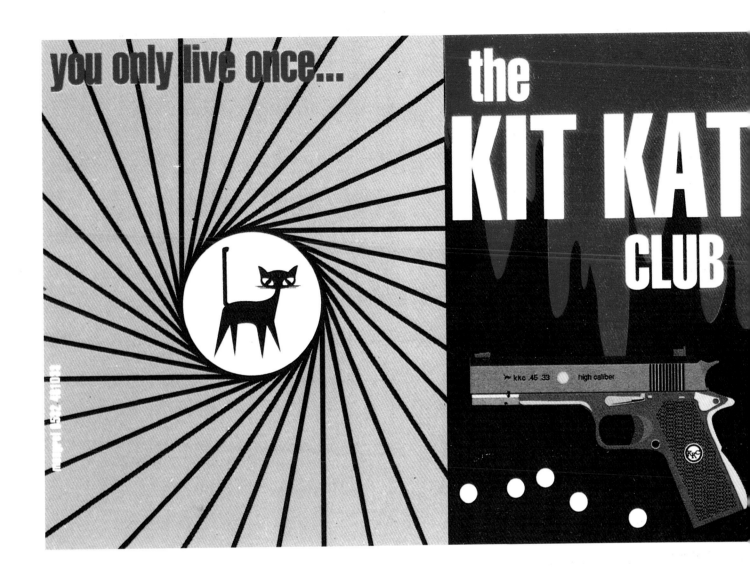

Kit Kat Club
Design. Mongrel Graphic
Date. 1992
Site. Kit Kat Club.
Leeds

Tigerlilly
Design. Leo Elstob
Date. 1995
Site. The Academy.
Uxbridge

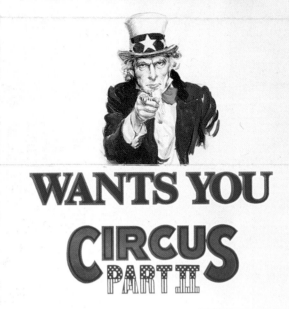

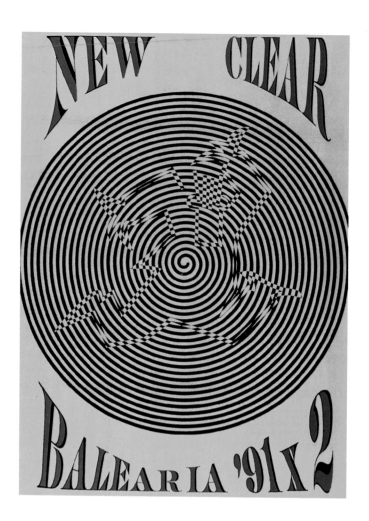

Circus Part 2
Date. 1991
Site. Kent
unfolded

New Clear Balearia 2
Date. 1991
Site. Marcus Garvey Centre.
Nottingham

RAVESTOCK AT WOODSTOCK 94

SAUGERTIES
New York
August 12th-14th

3 DAYS of LOVE & DANCE

LIVE AND DIRECT
THE ORB (2 SHOWS)
ORBITAL
DEEE-LITE

WITH DJ'S
LITTLE LOUIE VEGA
ALEX PATERSON
FRANKIE BONES
DJ LEWIS
DOC MARTIN
KEVIN SAUNDERSON
RICHARD JAMES (APHEX TWIN)

Ravestock
Design. Liquid Sky
Date. 1994
Site. Winston Farm.
New York

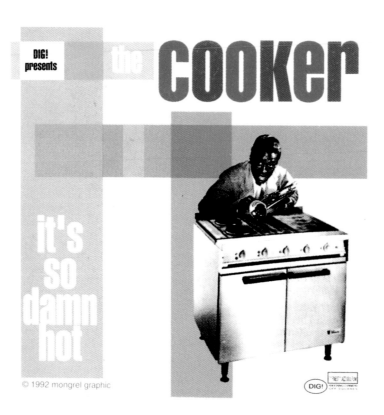

DIG! presents **the COOKER**

it's so damn hot

© 1992 mongrel graphic

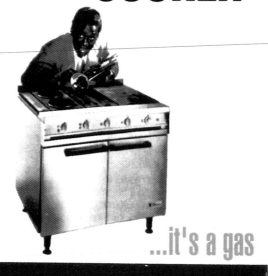

the COOKER

...it's a gas

The Cooker
Design. Mongrel Graphic
Date. 1992
Site. Arcadia.
Leeds

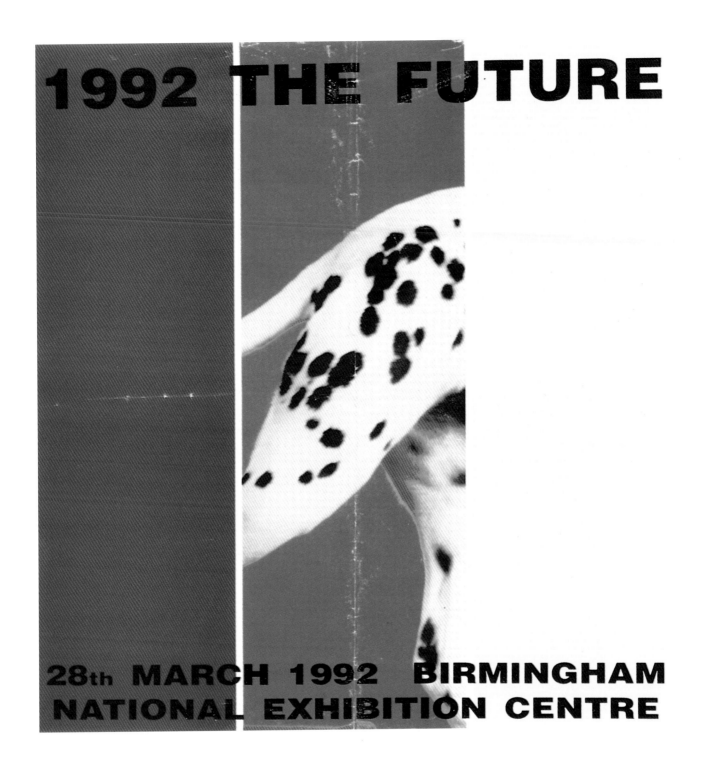

1992 THE FUTURE

28th MARCH 1992 BIRMINGHAM NATIONAL EXHIBITION CENTRE

The Future
Date. 1992
Site. N.E.C.
Birmingham

THE WO
(Legal Licen
TWO DAY DA
DREA
SETTING THE ST.

WOO
THE NE

FRIDAY 20TH AUGUST 1
We at ESP Promotions will be attempting to st
No other dance organisation will equal the size &

HISTO

WAVED

DREAMSCAPE

Woodstock 2
Design. Adrenalin Corporation
Date. 1993
Site. Fen Farm.
Milton Keynes
unfolded

LD'S LARGEST
(Event Capacity 30,000+)
CE MUSIC FESTIVAL

MSCAPE

DARD FROM START TO FINISH

STOCK 2

GENERATION
FROM

3 TO SUNDAY 23RD AUGUST 1993

he world's first & largest two day(All Nighters) Dance music Festival.
uide of this once in a life time event. 37 hours of non stop dance music

IN THE MAKING

THE VENUE,
ASS LAND IN THE HEART OF ENGLAND
EN FARM
NCTION 14 M1

MILTON KEYNES

DREAMSCAPE

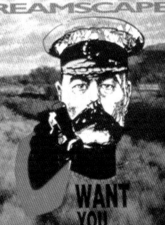

WANT YOU

HELP US SINK MILTON KEY
GOD SAVE DANCE MUSIC

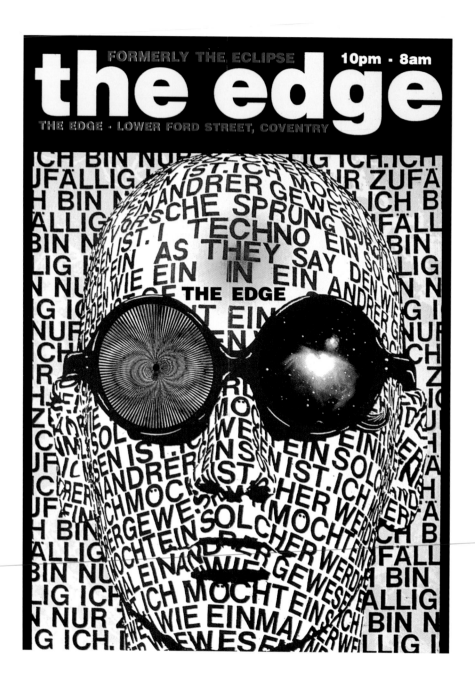

The Edge
Date. 1992
Site. The Edge.
Coventry

Fool-Proof
Date. 1991
Site. Hummingbird Centre.
Birmingham

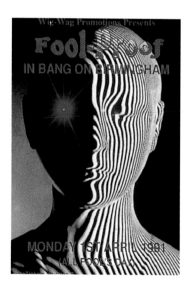

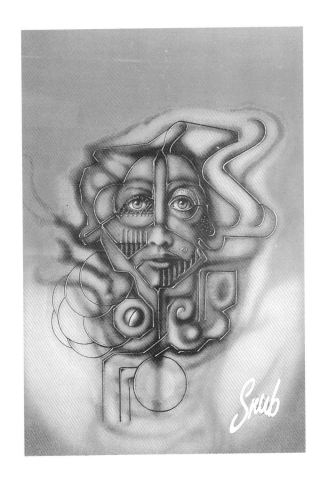

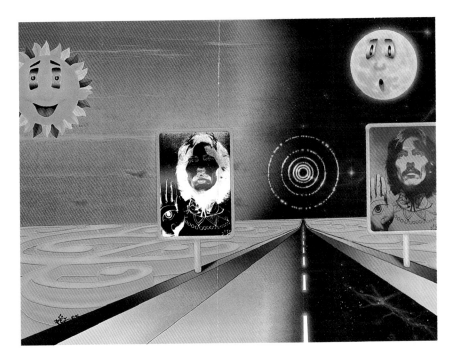

Snub
Date. 1991
Site. JJ's. Willenhall

The Twilight Zone
Design. Pez
Date. 1992
Site. The Roller Express.
London

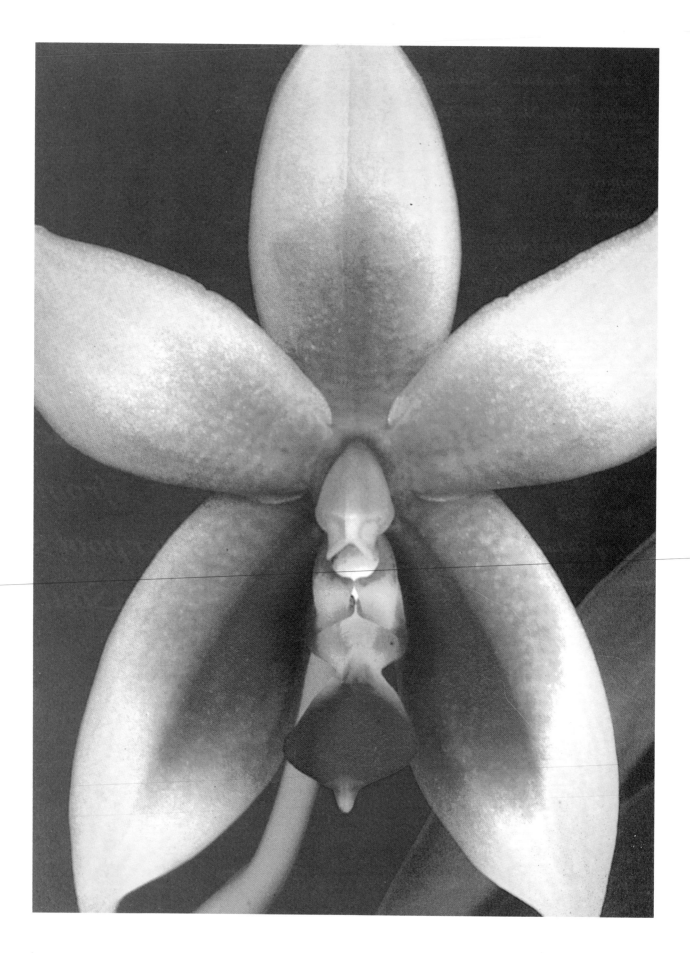

Deep & Devastating
Design. Shed
Date. 1992
Site. Academy.
Liverpool
unfolded

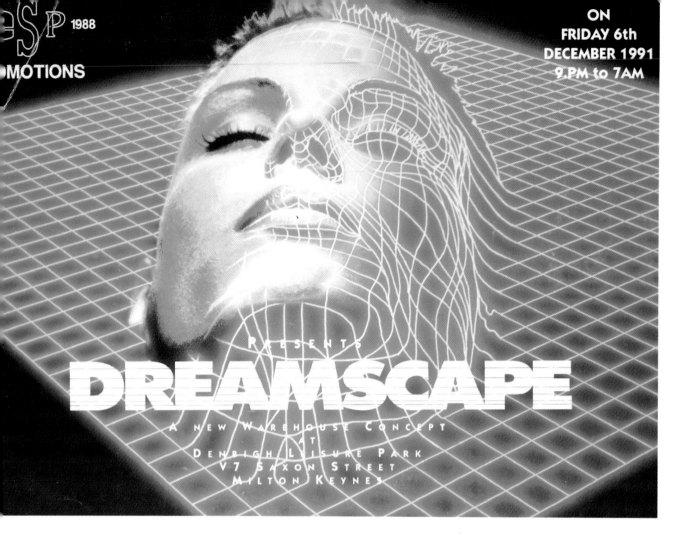

ESP 1988
PROMOTIONS

ON
FRIDAY 6th
DECEMBER 1991
9.PM to 7AM

PRESENTS

DREAMSCAPE

A NEW WAREHOUSE CONCEPT
AT
DENBIGH LEISURE PARK
V7 SAXON STREET
MILTON KEYNES

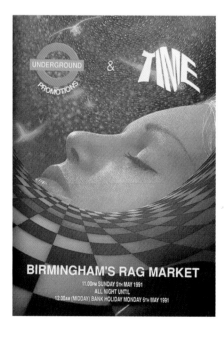

Dreamscape
Design. ESP and Design Art
Date. 1991
Site. Denbigh Leisure Park.
Milton Keynes

Together
Date. 1991
Site. Rag Market.
Birmingham

 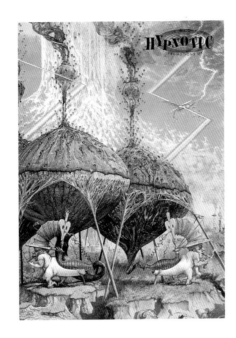 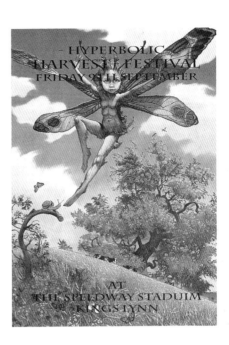

Eden
Date. 1991
Site. New Forest.
Hampshire

Hypnotic
Date. 1991
Site. The Eclipse.
Coventry

Hyperbolic
Design. ADG
Date. 1992
Site. Speedway Stadium.
Kings Lynn

RAINDANCE² 91

THE EGG

·PEZ· Ⓗ

Raindance 91 The Egg
Design. Pez
Date. 1991
Site. Barking
opposite

Head
Date. 1991
Site. Starlite 2001.
Leicester

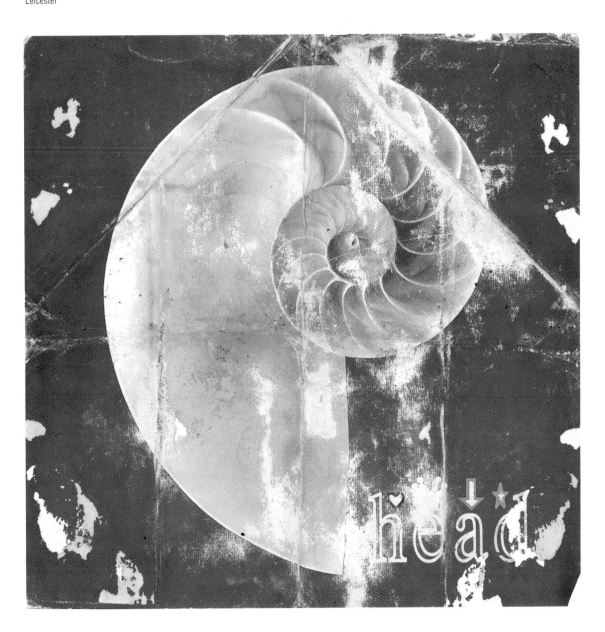

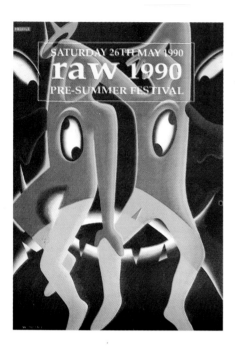

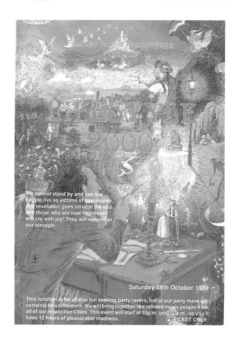

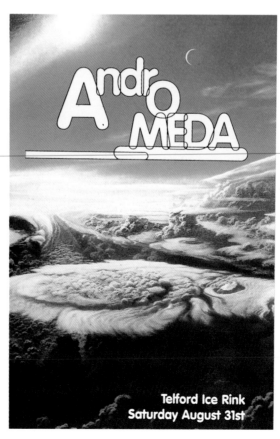

Raw
Date. 1990
Site. Midlands

Lifestyle 2000
Date. 1989
Site. Birmingham

Andromeda
Date. 1991
Site. Ice Rink.
Telford

Telepathy
Design. Pez
Date. 1991
Site. Marshgate Lane
London

Real and true art never conforms but stands against the wall of the establishment unashamed, living, breathing. Only death can be found there whilst self-appointed geriatric critics argue of intention long after the truth is dead.

Pez **100995**

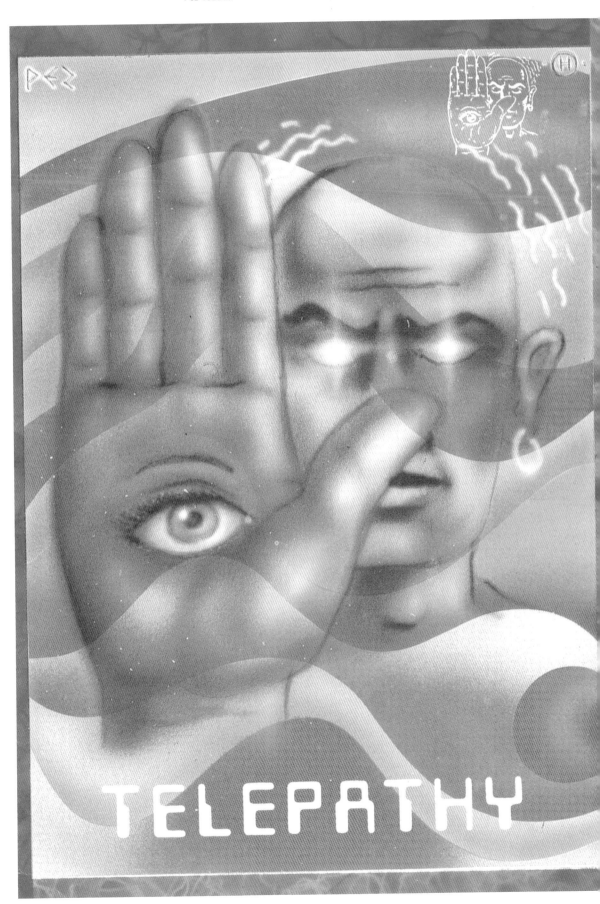

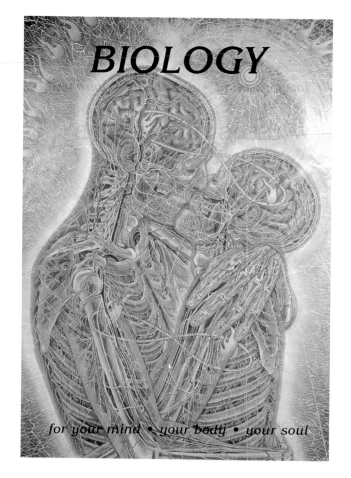

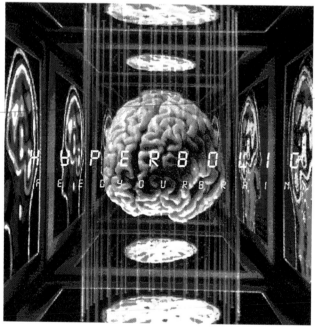

Biology
Date. 1990
Site. Trades Club.
Leeds

Hyperbolic
Design. ADG
Date. 1994
Site. Speedway Stadium.
Kings Lynn

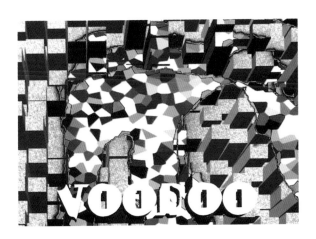

Voodoo
Design. Nonconform and Skitch
Date. 1994
Site. Le Bateau.
Liverpool

Always in vain I try to convince people that abstract, trippy and sinister is better than sexy, fruity and nice, the difference between right and wrong, basically.

Skitch Voodoo **310895**

Pulse
Date. 1990
Site. Birmingham

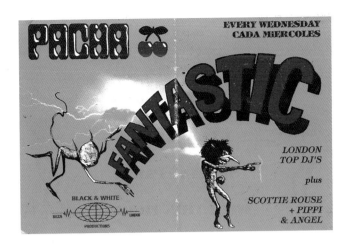

Fantastic
Date. 1990
Site. Pacha. Ibizia

Zest
Illustration. Yolhafta Tekyaredoff
Date. 1992
Site. Venue 44.
Mansfield

Time Out
Design. Strobe
Date. 1990
Site. Birmingham

DREAM ZONE

© JUNIOR TOMLIN 93

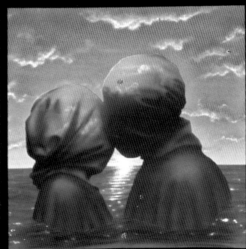
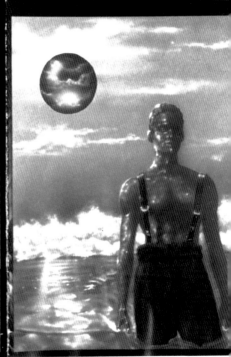

RAINDANCE²

CLIMACTIC
COMMUNION

Dream Zone
Design. Junior Tomlin
Date. 1993
Site. Leas Cliff Hall.
Folkstone

Raindance 2
Design. Pez
Date. 1991
Site. Barking
unfolded

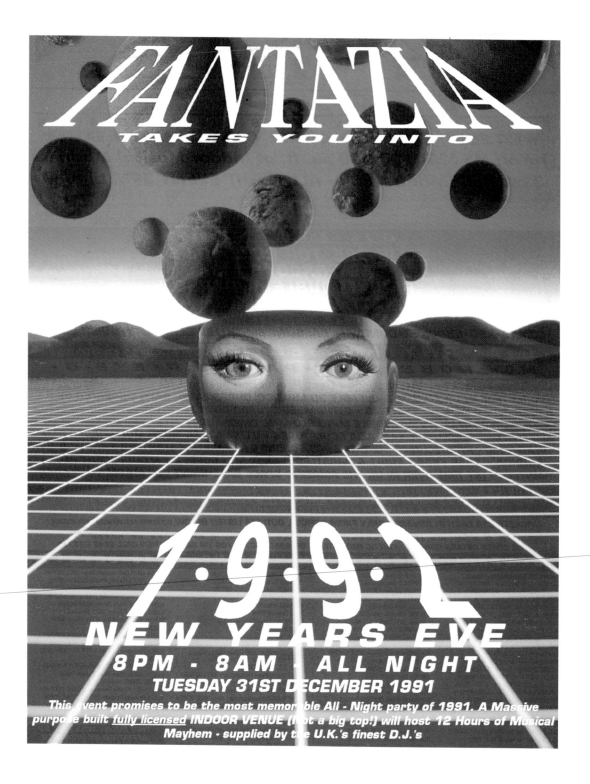

Fantazia
Design. Alex
Date. 1991
Site. West Point Exhibition Centre.
Exeter

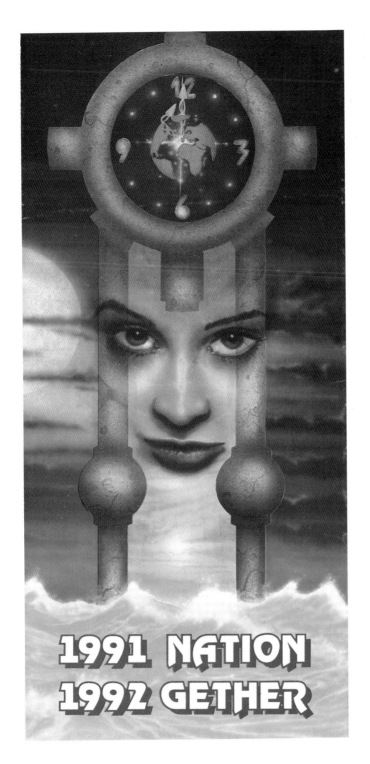

Raindance
Date. 1991
Site. Melton Mowbray

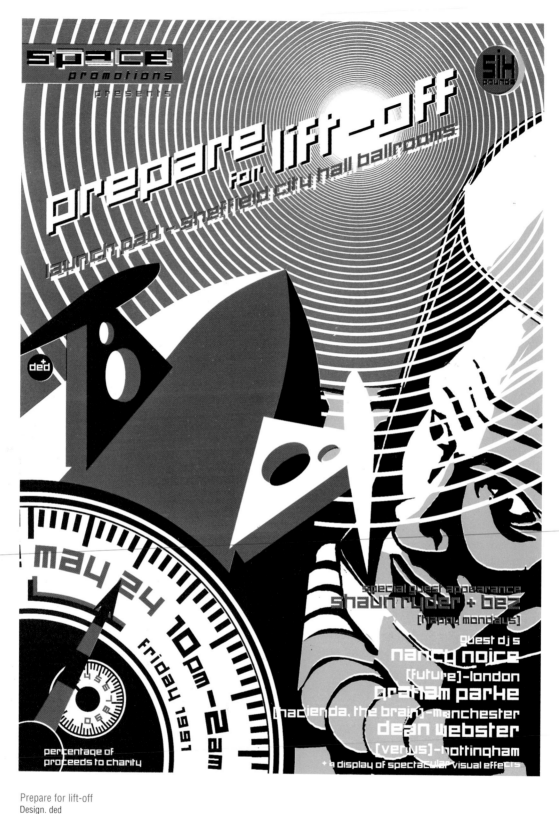

Prepare for lift-off
Design. ded
Date. 1991
Site. City Hall Ballrooms.
Sheffield

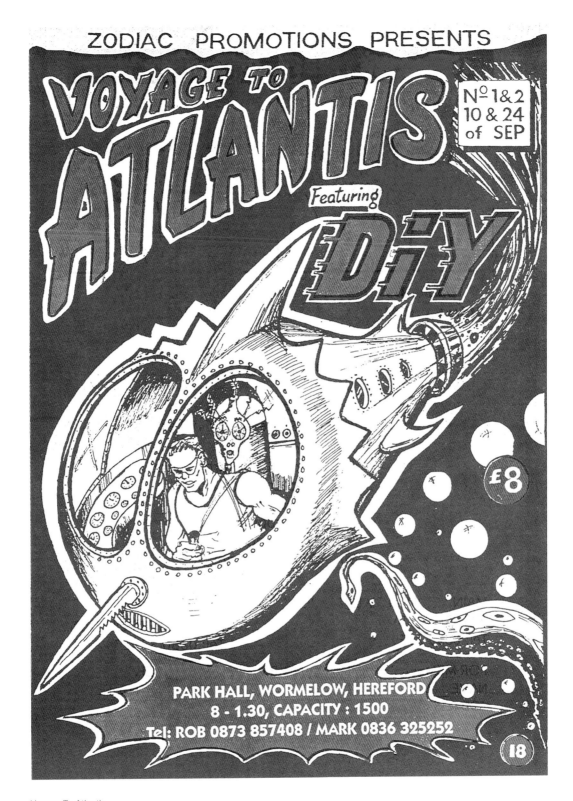

Voyage To Atlantis
Date. 1993
Site. Park Hall.
Hereford

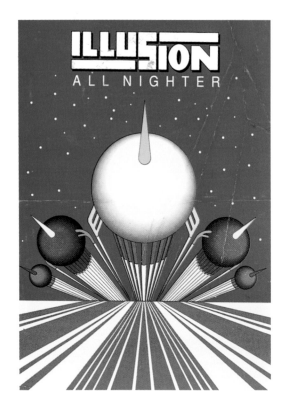

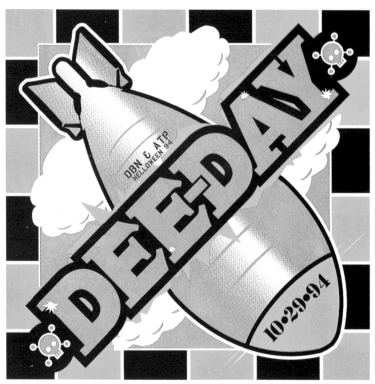

Illusion
Date. 1992
Site. Keele University.
Newcastle-under-Lyme

Dee-Day
Design. Drop Bass
Date. 1994
Site. Undee Room.
Chicago

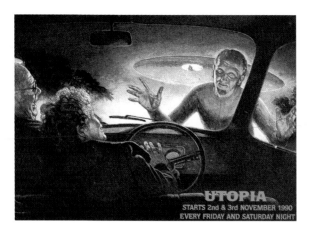

Utopia
Date. 1990
Site. The New Aero.
Birmingham

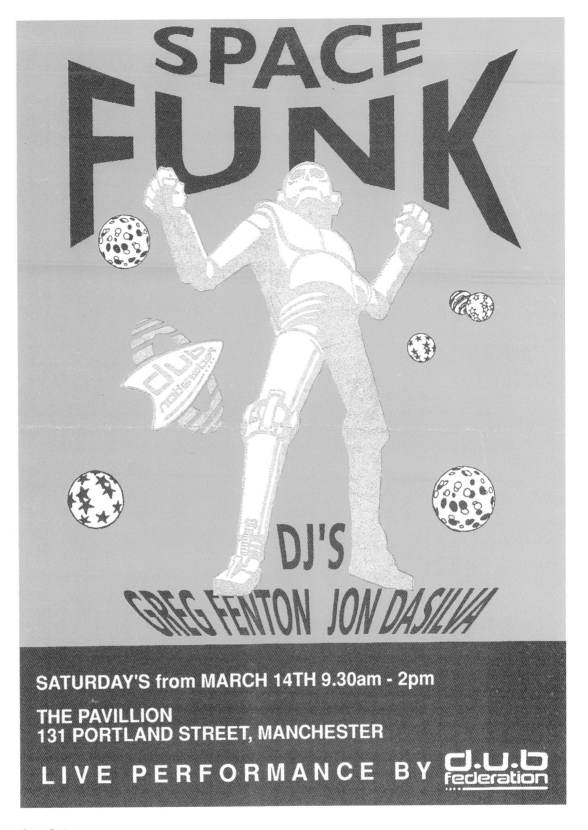

Space Funk
Date. 1991
Site. The Pavillion.
Manchester

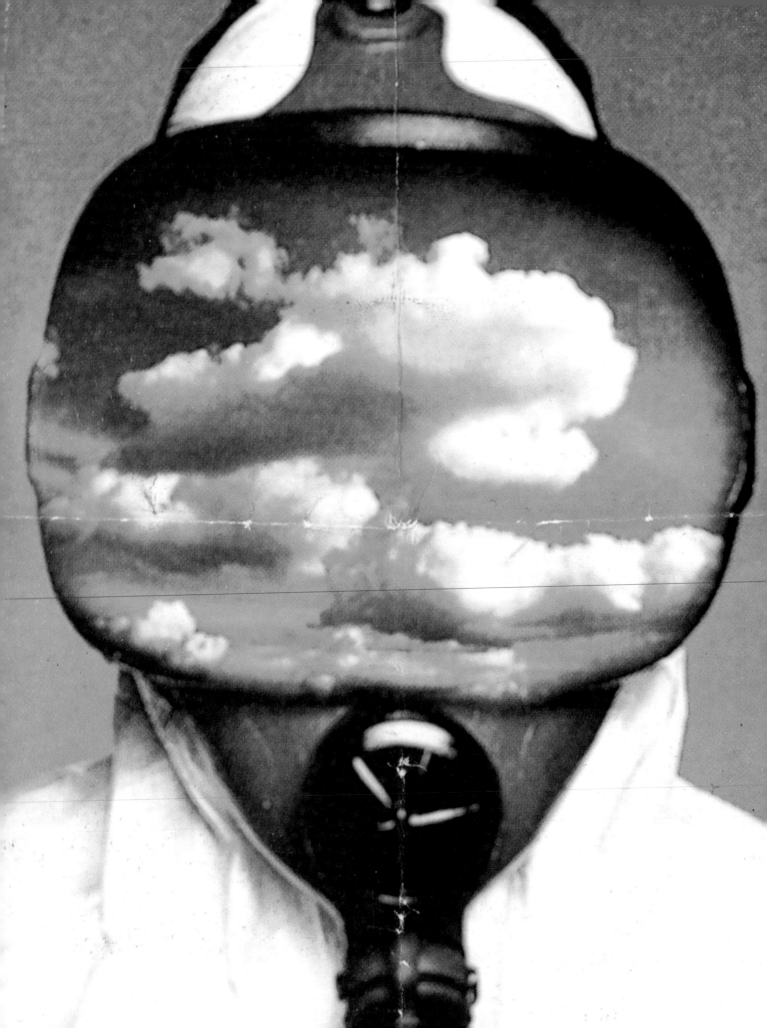

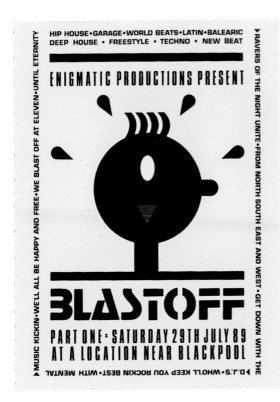

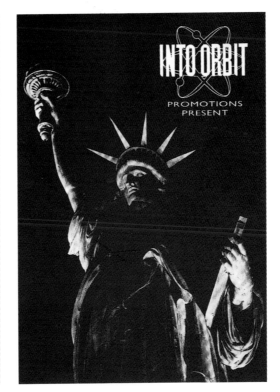

Awesome
Design. Corporate Slave
Date. 1992
Site. Marco's Forum.
Livingston
opposite

Blastoff
Date. 1989
Site. Blackpool

The Original Mission
Date. 1989
Site. London

New Years Eve Party
Date. 1990
Site. Aston Villa Sports Centre.
Birmingham

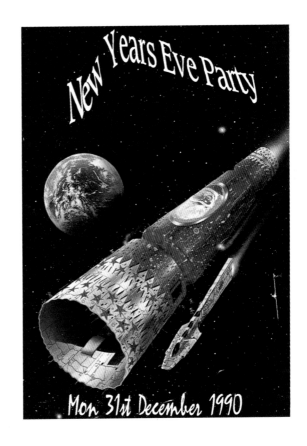

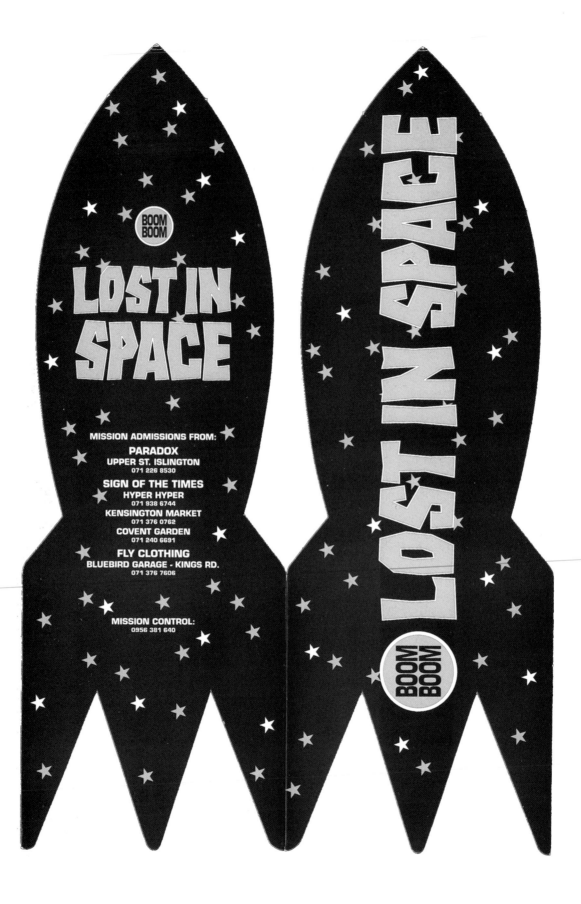

Lost In Space
Design. The Designers Republic
Date. 1992
Site. London
unfolded

Bazooka
Design. Leo Elstob
Date. 1994
Site. The Broadway.
Chesham

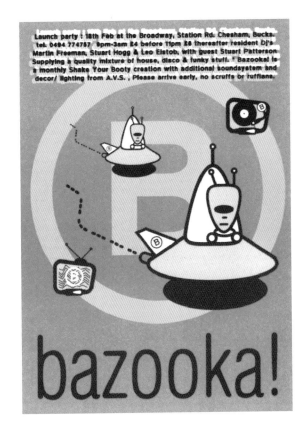

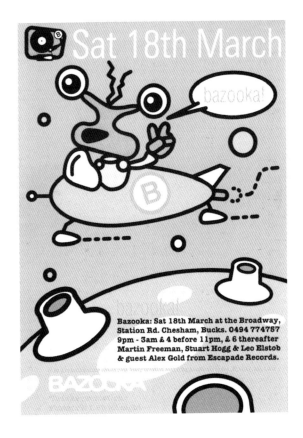

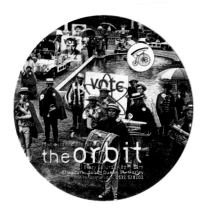
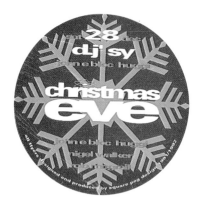
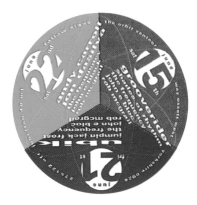
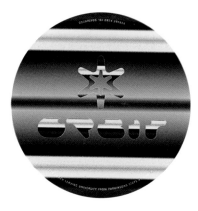

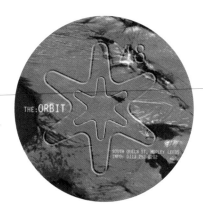

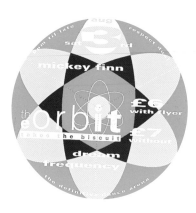

The Orbit
Design. AR:5E and SqaurePeg:Design
Date. 1991-1995
Site. Afterdark. Morley

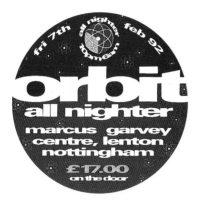

orbit
all nighter
marcus garvey
centre, lenton
nottingham
£17.00
on the door
fri 7th all nighter feb 92

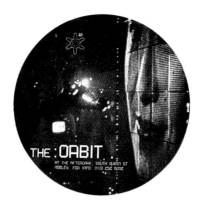

THE :ORBIT
AT THE AFTERDARK, SOUTH QUEEN ST
MORLEY. FOR INFO 0113 252 8200

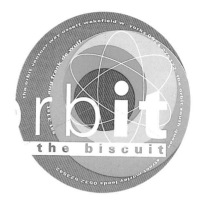

orbit
the biscuit

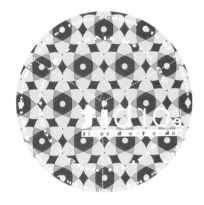

orbit
the biscuit

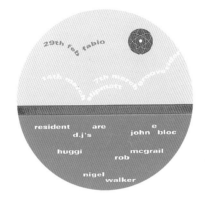

29th feb fabio
resident are
d.j's
huggi mcgrail
rob
nigel
walker
john e bloc

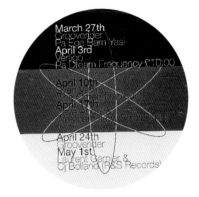

March 27th
Grooverider
Pa Ece Bam Yasi
April 3rd
Vertigo
Pa Dream Frequency £10.00
April 10th
Sven Väth
(Mag Ellen Frankfurt)
April 17th
Dave Angel
(Westbam Berlin split ability)
April 24th
Grooverider
May 1st
Laurent Garnier &
Cj Bolland (R&S Records)

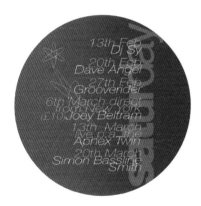

13th Feb
Dj Sy
20th Feb
Dave Angel
27th Feb
Grooverider
6th March direct
from New York
£10 Joey Beltram
13th March
live a
Aphex Twin
20th March
Simon Bassline
Smith

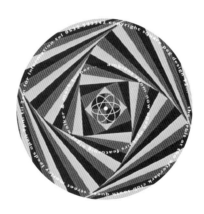

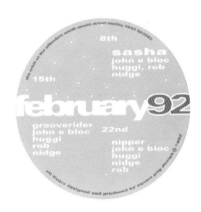

8th
sasha
john e bloc
huggi, rob
nidge
15th
february 92
grooverider
john e bloc
huggi
rob
nidge
22nd
nipper
john e bloc
huggi
nidge
rob

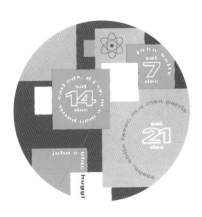

john kelly
sat
7
dec
sat
14
dec
sat
21
dec
john e bloc
huggi

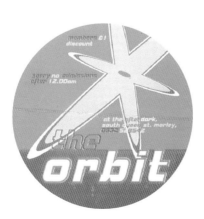

members £1
discount
sorry no admissions
after 12.00am
at the afterdark,
south queen st. morley,
the
orbit

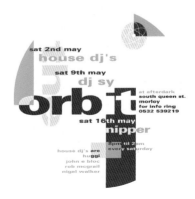

sat 2nd may
house dj's
sat 9th may
dj sy
orbit
at afterdark
south queen st.
morley
for info ring
0532 539219
sat 16th may
nipper
house dj's are
huggi
john e bloc
rob mcgrail
nigel walker
8pm til 2am
every saturday

Energy
Date. 1992
Site. The Eclipse.
Coventry

Starlight
Date. 1990
Site. Birmingham

COVENTRY ECLIPSE FRIDAY 21st JUNE 1991

Solstice
Date. 1991
Site. The Eclipse.
Coventry

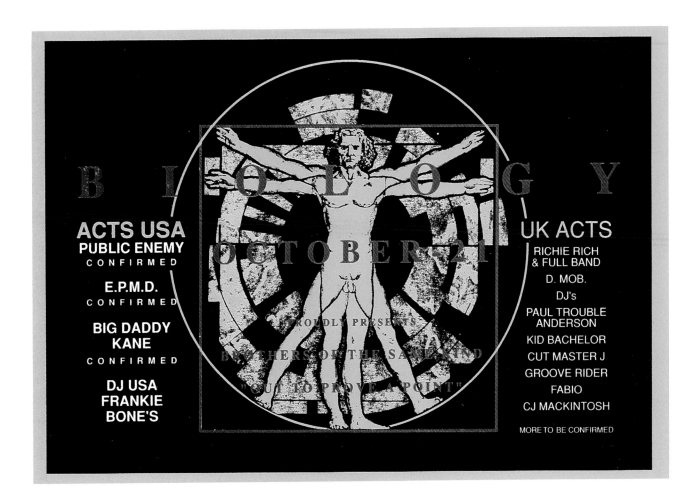

BIOLOGY

OCTOBER 21

PROUDLY PRESENTS

BROTHERS OF THE SAME KIND

"OUT TO PROVE A POINT"

ACTS USA
PUBLIC ENEMY
C O N F I R M E D

E.P.M.D.
C O N F I R M E D

**BIG DADDY
KANE**
C O N F I R M E D

**DJ USA
FRANKIE
BONE'S**

UK ACTS
RICHIE RICH
& FULL BAND

D. MOB.

DJ's

PAUL TROUBLE
ANDERSON

KID BACHELOR

CUT MASTER J

GROOVE RIDER

FABIO

CJ MACKINTOSH

MORE TO BE CONFIRMED

Biology
Date. 1990
Site. London

Spiritually Groovy
Design. Trade Mark
Date. 1989
Site. Limelight.
London

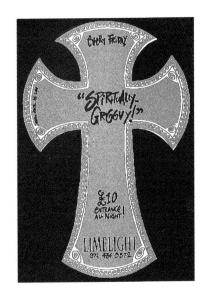

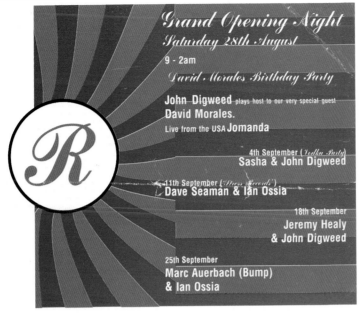

Grand Opening Night
Saturday 28th August

9 - 2am

David Morales Birthday Party

John Digweed plays host to our very special guest
David Morales.
Live from the USA **Jomanda**

4th September (*Vodka Party*)
Sasha & John Digweed

11th September (*Stress Records*)
Dave Seaman & Ian Ossia

18th September
**Jeremy Healy
& John Digweed**

25th September
**Marc Auerbach (Bump)
& Ian Ossia**

**The Conservatory
Willow Road
Central Derby**

every saturday 9 - 2am
admission £8
(£10 opening night)

existing Renaissance members welcome, for further infomation see flyers or call
Renaissance:
0782 714224 / 0782 711404

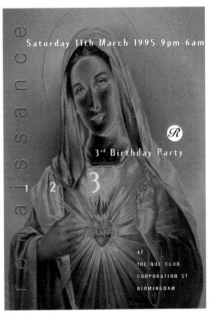

Renaissance
Design. Chris Howe
Date. 1994
Sites. Venue. Nottingham
The Conservatory. Derby
opposite and top

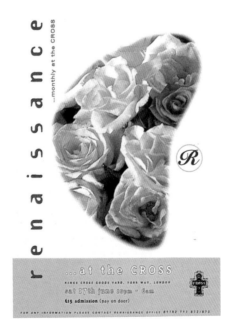

Renaissance
Design. Wise and Kormelink
Date. 1995
Site. The Cross.
London

Design. Wise and Kormelink
Date. 1995
Site. Que Club.
Birmingham

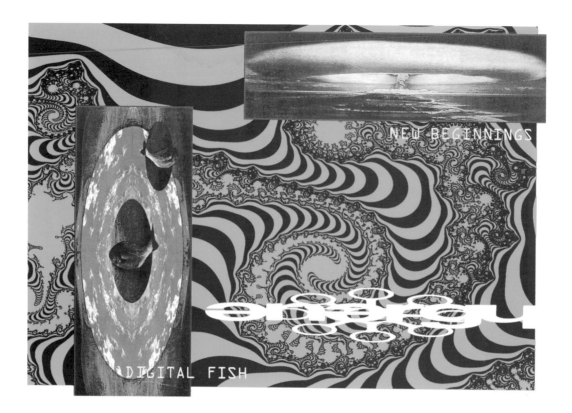

NEW BEGINNINGS

DIGITAL FISH

Energy
Date. 1991
Site. Quadrant Park.
Liverpool

I think Quadrant Park was the right time,
the right place with the right people.
Unfortunately, you will never equal that.
I've always said Quadrant Park was the best,
strongest experience I've had in my life. Back
in the 1980s I saw the Haçienda going loopy,
crazy, stupid, but Quadrant Park was even
stronger than that.

Laurent Garnier **300695**

Dream
Design. Mongrel Graphic
Date. 1991
Site. Trades Club.
Leeds

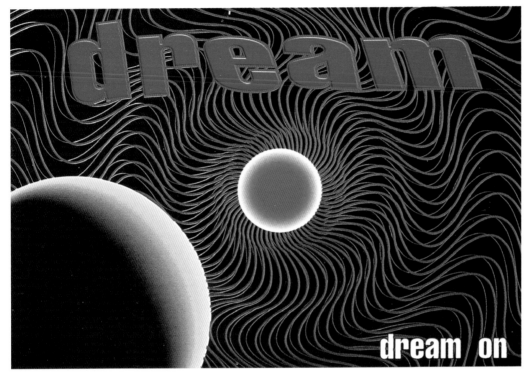

dream on

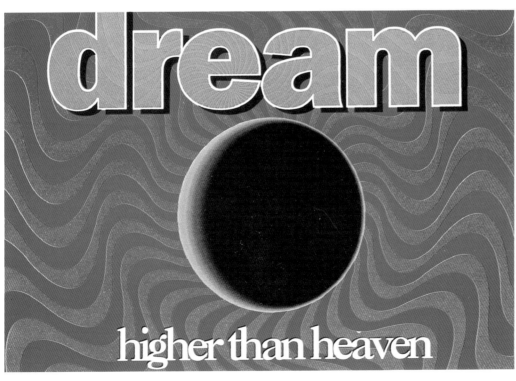

higher than heaven

My favourite flyer is the first flyer that Dream produced to promote the legendary Dream night at the Leeds Trades Club in 1991. The night only ran for two months but it was a massive success and people still talk about it today. In 1991 the clubs were not as established, there were more one-off nights and warehouses were on the go so flyers played a major role in the promotion of nights.

Christopher Ferguson Dream FM **300695**

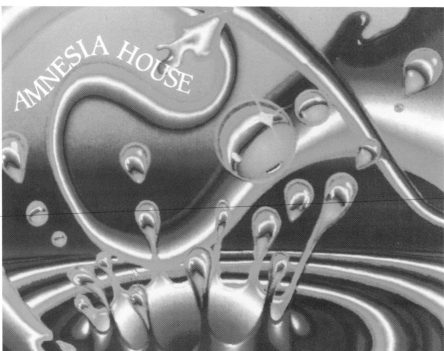

Vision On
Date. 1989
Site. The Rocket.
London

Amnesia House
Date. 1992
Site. The Eclipse.
Coventry

Design. Adrenalin Corporation
Date. 1992
Site. The Edge.
Coventry
opposite

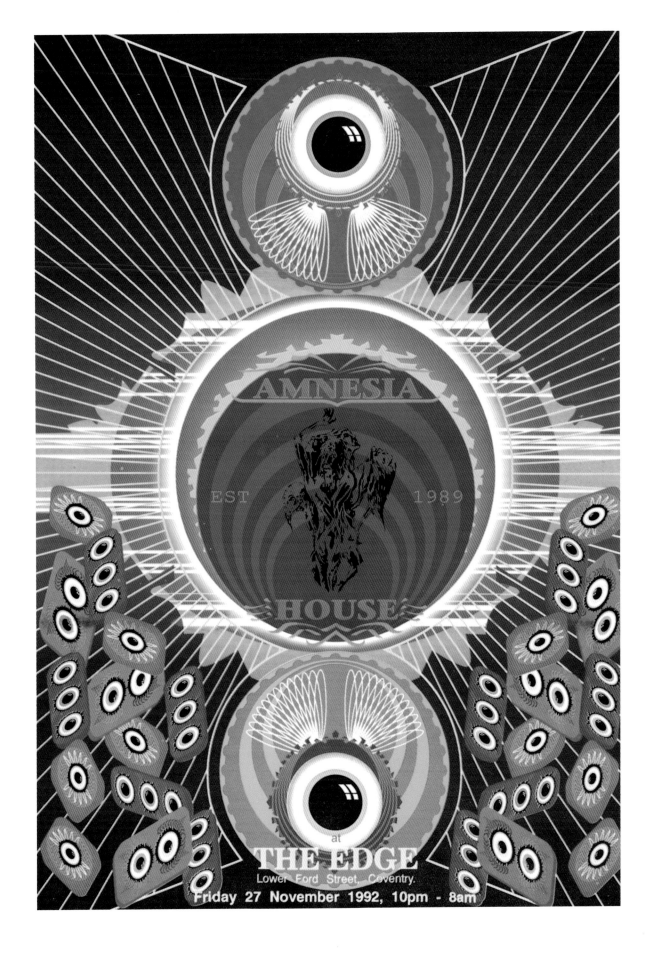

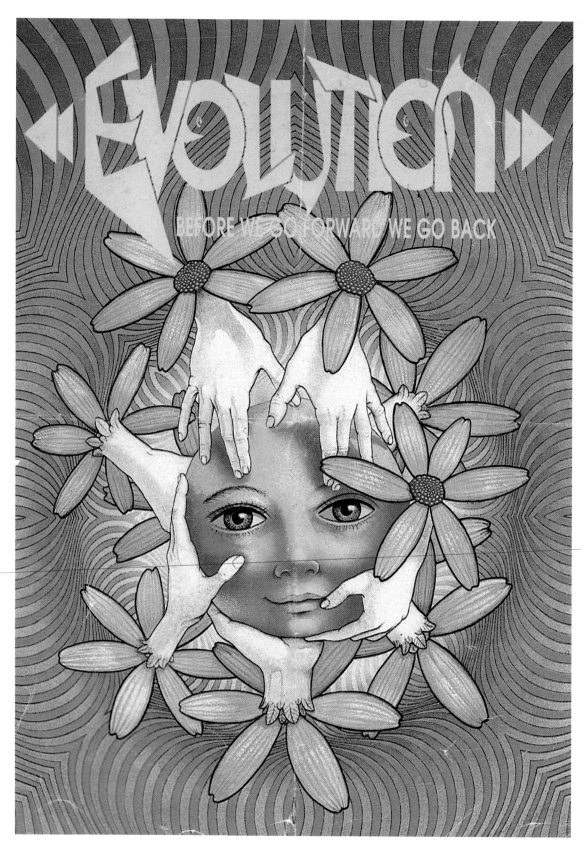

Evolution
Design. Pop
Date. 1990
Site. The Astoria.
London

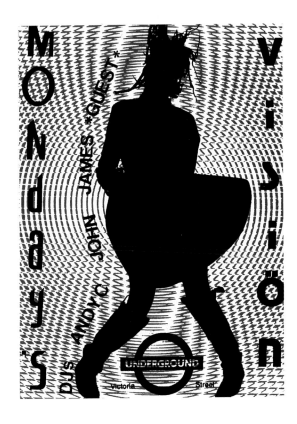

Vision
Design. James Barton
Date. 1989
Site. Underground.
Liverpool

Energy
Date. 1989
Site. Brixton Academy.
London

Atomic
Design. Mongrel Graphic
Date. 1990
Site. AJ's. Bradford

Resurrection
Date. 1989
Site. London

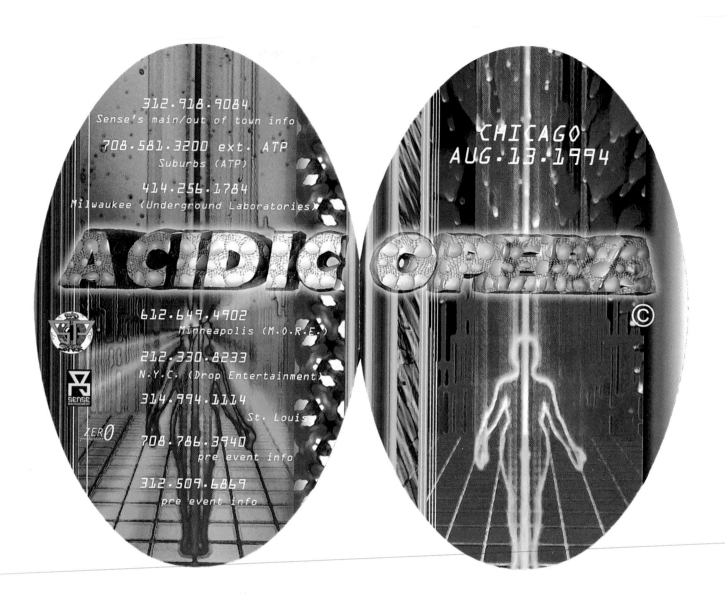

312.918.9084
Sense's main/out of town info

708.581.3200 ext. ATP
Suburbs (ATP)

414.256.1784
Milwaukee (Underground Laboratories)

ACIDIC

612.649.4902
Minneapolis (M.O.R.E.)

212.330.8233
N.Y.C. (Drop Entertainment)

314.994.1114
St. Louis

708.786.3940
pre event info

312.509.6869
pre event info

CHICAGO
AUG·13·1994

OPERA

Acidic Opera
Design. Durica Design
Date. 1994
Site. Chicago
unfolded

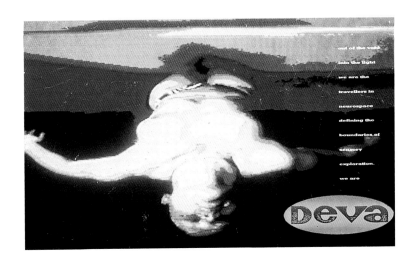

Rush
Date. 1991
Site. Sedgwick Dance Studios.
London

Deva
Design. 3rd-i-Design
Date. 1991
Site. Park Hall.
Charnock Richard

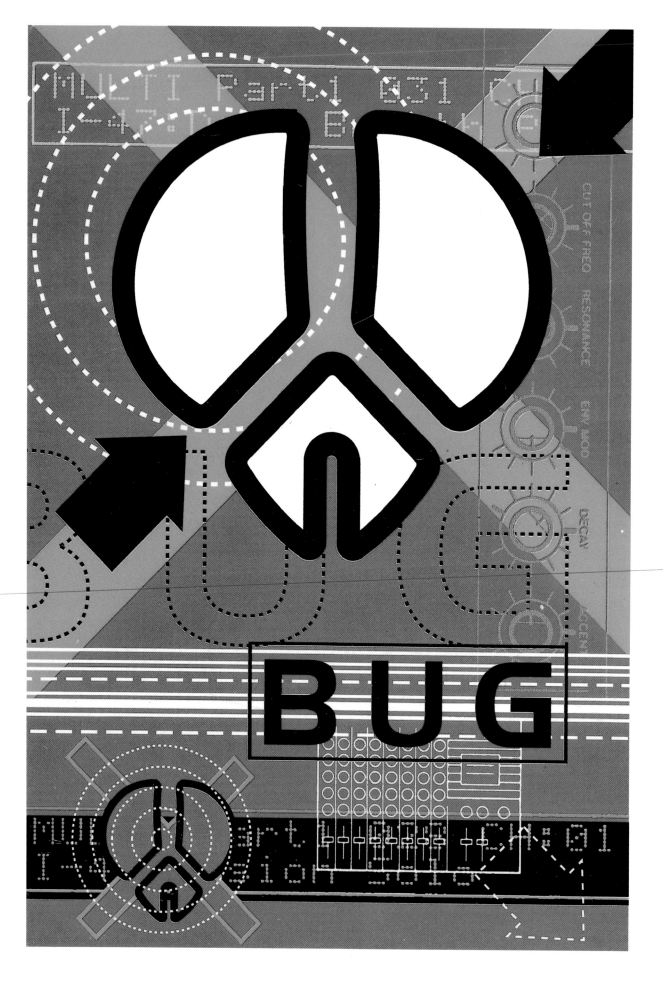

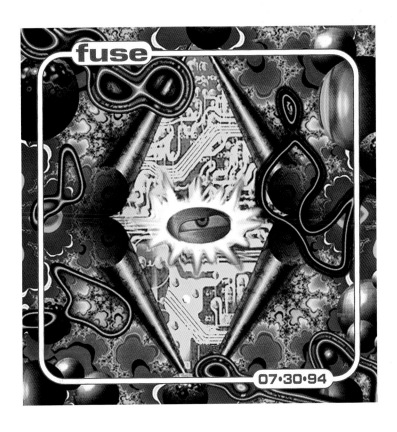

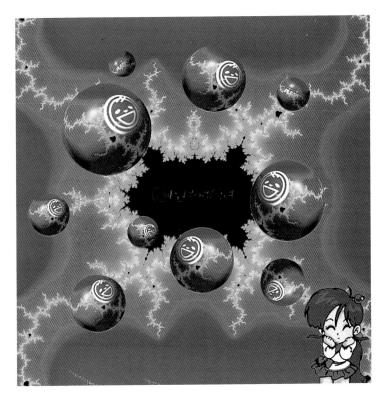

Bug
Design. Rob Wallis and Jonathon Cooke
Date. 1994
Site. Dingwalls.
London
opposite

Fuse
Design. 43d
Date. 1994
Site. Chicago

Pleasure
Design. Undercover
Date. 1995
Site. Wigan Pier.
Wigan

Sonic
Design. Corporate Slave
Date. 1991
Site. Academy.
Liverpool

Energy
Date. 1989
Site. London

Arena
Design. Tony Quinn and Red Door
Date. 1991
Site. Roundhay Park.
Leeds

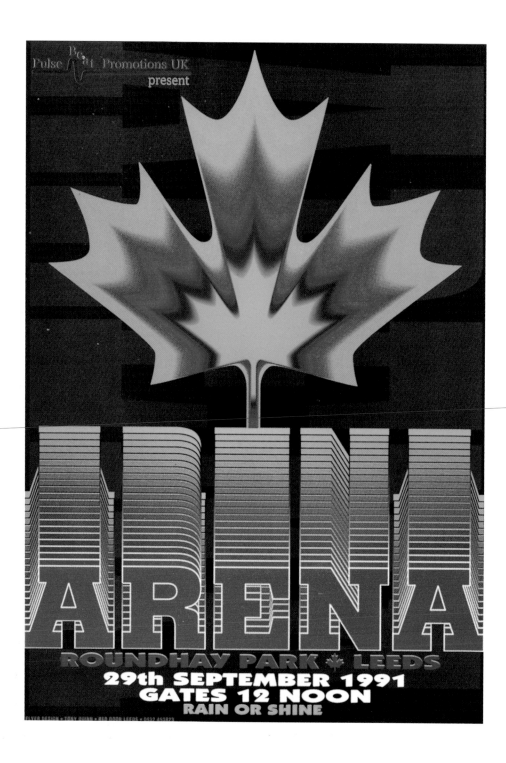

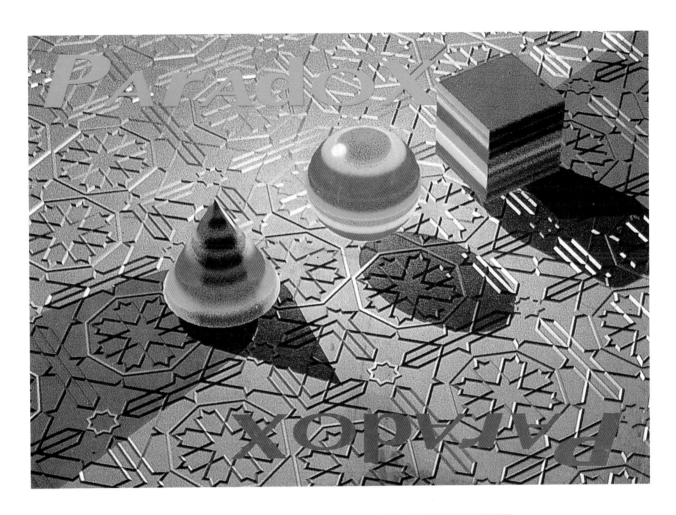

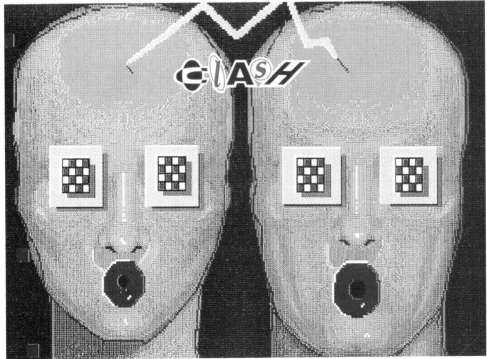

Paradox
Design. Dave Steele
Date. 1992
Site. Summer Down Farm.
Everleigh

Clash
Date. 1992
Site. Hippodrome.
Manchester

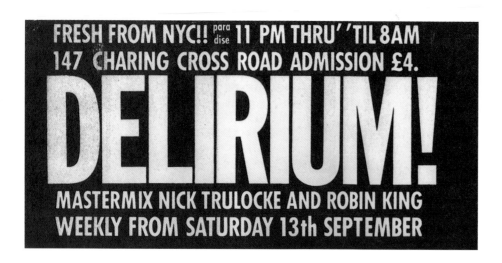

FRESH FROM NYC!! para dise **11 PM THRU' 'TIL 8AM**
147 CHARING CROSS ROAD ADMISSION £4.

DELIRIUM!

MASTERMIX NICK TRULOCKE AND ROBIN KING
WEEKLY FROM SATURDAY 13th SEPTEMBER

NICK TRULOCKE PRESENTS AN UNDERGROUND RAVE
SATURDAYS OFFICIAL OPENING NIGHT AUG 5. 1989 10.30 PM – 3.30 AM

DESIRE!

ADMISSION TICKET HOLDERS £5 **FEATURING DJ's LEE & PAUL GIBSON** WITHOUT TICKET £6
THE BASEMENT 79 OXFORD ST. RIGHT OF ADMISSION RESERVED

ANARCHIKSKACASUALPATWAAPACHIESKINKLEOPATRAKATWALKIN
11 · THEED STREET · LONDON WATERLOO SE1

LONDON

SATURDAY 20 · SKAT £5 DONATION
INTO THE AGE OF AQUARIUS
AUGUST 1988
JUST OVER WATERLOO BRIDGE LEFT INTO STAMFORD ST, RIGHT CORNWALL RD, LEFT THEED ST
TONY WILSON · **BALEARIC** · COLIN DALE · **KISS** · FABIO · **PHASE I** · IN 10,000 SQ. FT. OF **MYSTERY**

Probably my favourite flyer was from Skat - one of the first
warehouse parties I ever attended. The design is quite minimal
and uncluttered. The basic design was a two colour print on one-
sided card. There were no trippy logos either to detract your
attention. There was a suspicious looking micro dot on it which
has been subliminally stuck in my mind (and bloodstream) since.
Notice the £5 donation, rather than the admission prices of
today. There was no door policy so everyone I went with got in!

Andy Martin Fatcat Records **250795**

Delirium
Design. Simon Taylor
Date. 1986
Site. The Astoria.
London

Desire
Design. Simon Taylor
Date. 1989
Site. The Basement
London

Skat
Date. 1988
Site. 11 Theed Street.
London

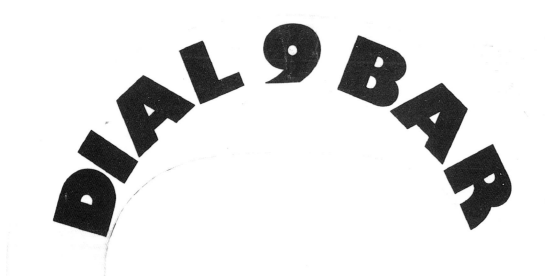

DIAL 9 BAR

A DELIRIUM ORGANISATION PRESENTATION

TWO FLOORS TWO SOUNDS

Every Saturday 9 p.m. — 3 a.m.

OPENING NIGHT — AUGUST 8th

10 ARGYLL STREET. W.1 ADMISSION £2.00

DELIRIUM!

SATURDAY 15th NOVEMBER 10-3.30am 147 CHARING CROSS RD £5
SHERRON AND PURE SEX DJ'S NOEL & MAURICE DAVE DORRELL
THIS TICKET INSURES ADMISSION

Dial 9 Bar
Design. Simon Taylor
Date. 1986
Site. 10 Argyll Street.
London

Delirium
Design. Simon Taylor
Date. 1987
Site. The Astoria.
London

Sin
Design. George Georgiou
Date. 1988
Site. Busbys.
London

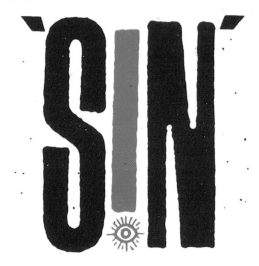

One Nation
Design. Art 21
Date. 1989
Site. Film Studio.
London

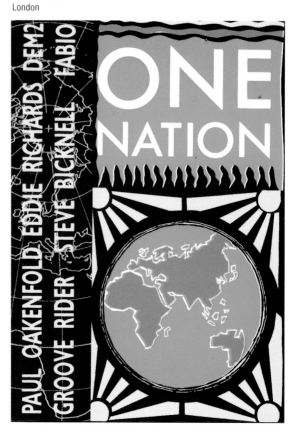

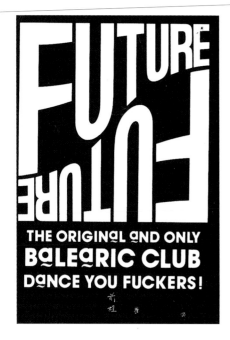

Future
Date. 1988
Site. London

L-dopa
Design. Mongrel Graphic
Date. 1991
Site. The Leadmill.
Sheffield

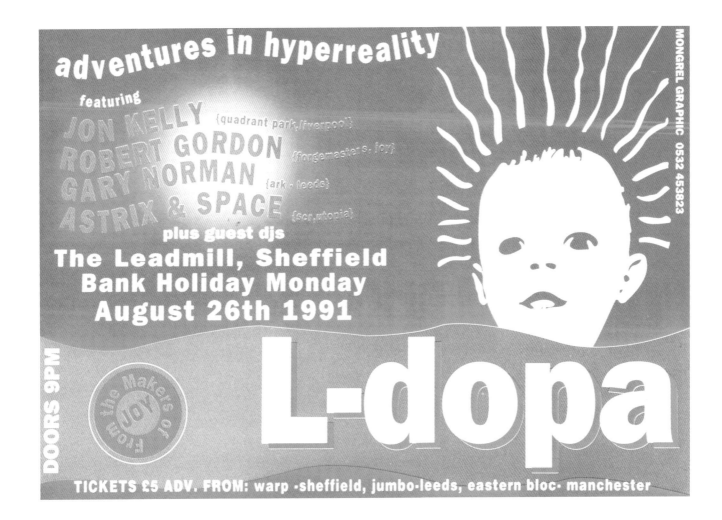

I don't know if I'd go as far as to call flyers "art" but I think that they are remarkable and important pictures from a very special point in the development of late 20th century society. Mongrel Graphic have been creating designs for clubs since 1991. Our job extended to developing the actual concept of the club nights themselves and as such, I see flyers as instrumental in shaping the dance music scene and ultimately the music of the clubs. They look nice too.

Paul Fryer Mongrel Graphic **210895**

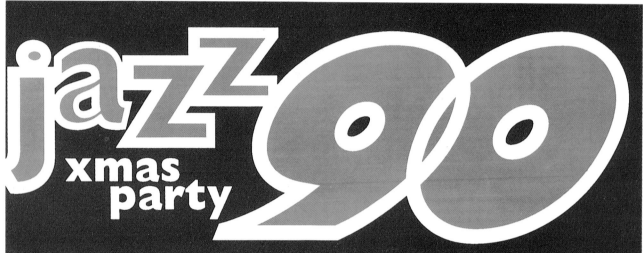

On : **Friday 20th December 1991** At : 5 Torren St, (Behind Angel Tube) Islington, London.

DJ's : Gilles Peterson + Sylvester 10.00 pm till 4am **£5 with this leaflet £6 on door**

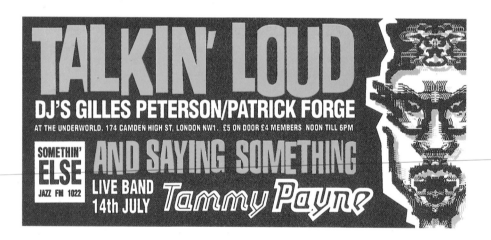

Jazz 90
Design. Swifty
Date. 1991
Site. 5 Torren Street.
London

Talkin' Loud
Design. Swifty
Date. 1991
Site. The Underworld.
London

Power Jazz
Design. Swifty
Date. 1994
Site. Young Street.
London

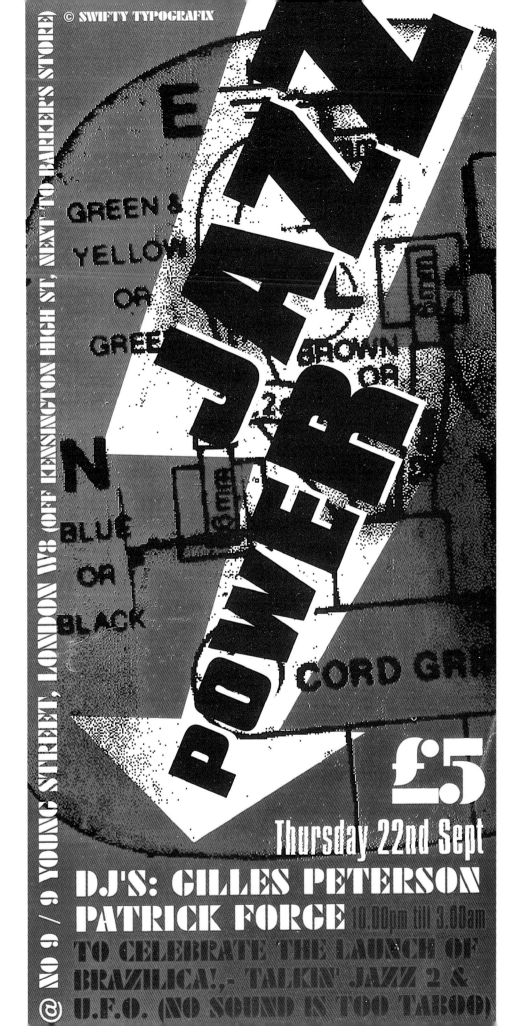

E

GREEN &

YELLOW

OR

GREE

BROWN OR

N

BLUE

OR

BLACK

CORD GR

JAZZ POWER

£5

Thursday 22nd Sept

DJ'S: GILLES PETERSON PATRICK FORGE 10.00pm till 3.00am

TO CELEBRATE THE LAUNCH OF BRAZILICA! - TALKIN' JAZZ 2 & U.F.O. (NO SOUND IS TOO TABOO)

@ NO 9 / 9 YOUNG STREET, LONDON W8 (OFF KENSINGTON HIGH ST, NEXT TO BARKER'S STORE)

Golden
Design. SquarePeg:Design
Date. 1994
Site. The Academy.
Stoke-on-Trent

We were influenced greatly by Peter Saville's designs for Factory Records. Recently we have "lifted" ideas from Pop artist Robert Indiana and Op artist Bridgit Riley. We don't use sexist images of women because we don't want to attract horny men.

John Hill Golden **150895**

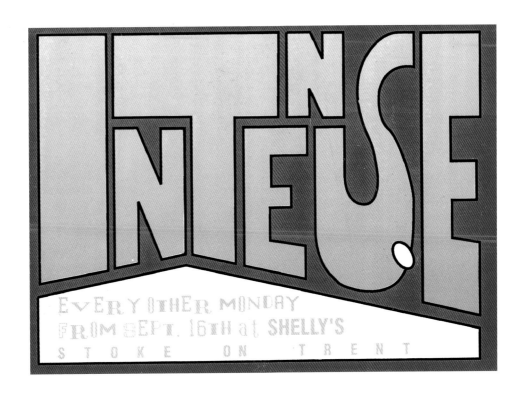

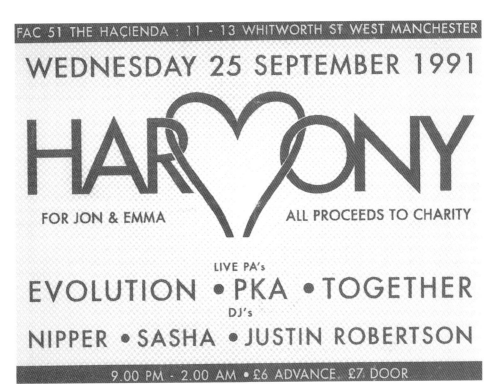

Intense
Date. 1990
Site. Shelly's.
Stoke-on-Trent

Harmony
Date. 1991
Site. The Haçienda.
Manchester

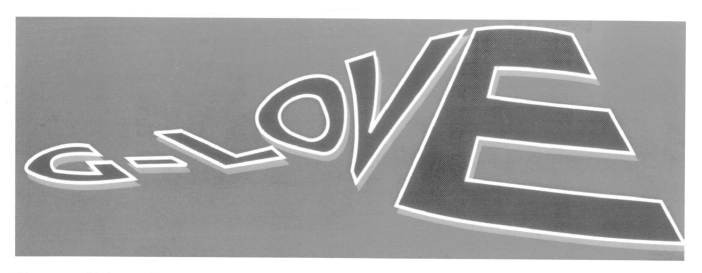

G-Love was possibly the most exclusive club night of 1991. While there are many ingredients that make a successful night, the first G-Love flyer kick-started the public's love affair with the place. It became incredibly sought after. The design complimented and influenced the music played by our resident DJ John Kelly. We decided to spend what in those days was silly money on the flyer but more importantly made the initial design exclusive and collectable. That for me signalled the start of something special. Four years on the night and the flyer is still held in high esteem.

Jon Barlow G-Love **210895**

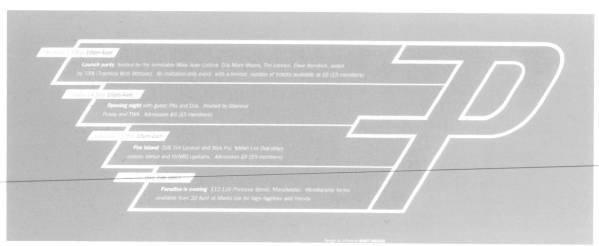

G-Love
Design. Ian Molyneux
Date. 1991
Site. Mardi Gras.
Liverpool

Paradise is coming
Design. Influence
Date. 1993
Site. Paradise Factory.
Manchester
back

Vapourspace
Design. 003 and Autofac
Date. 1994
Site. Grays.
London

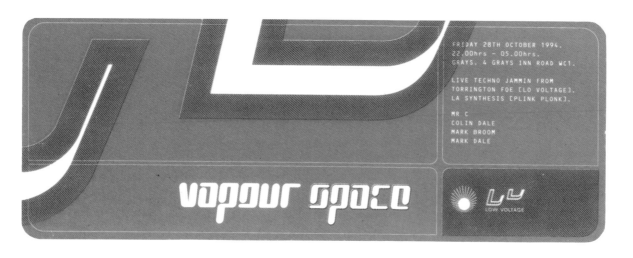

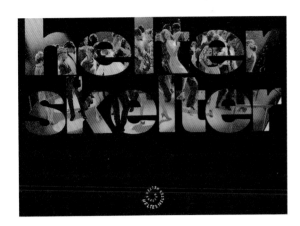

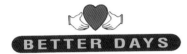

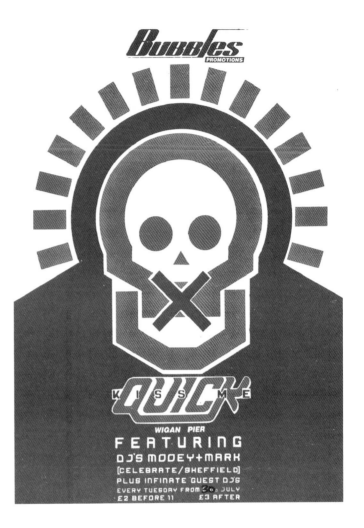

Kiss Me Quick
Date. 1991
Site. Wigan Pier.
Wigan

Helter Skelter 2
Design. Cosmo Cat
Date. 1991
Site. The Eclipse.
Coventry

Better Days
Date. 1992
Site. Venus.
Nottingham

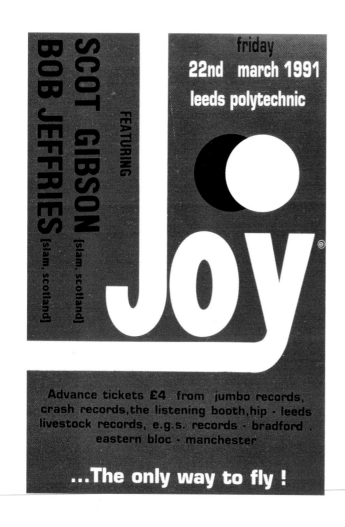

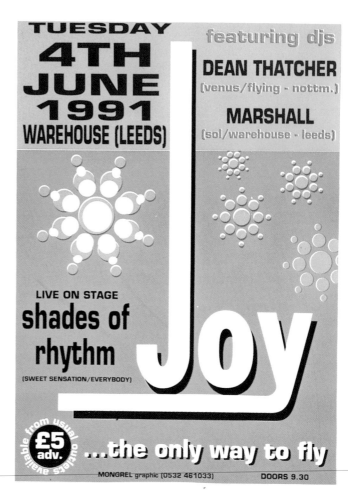

Joy
Design. Mongrel Graphic
Date. 1991
Sites. Leeds Polytechnic. Leeds
The Warehouse. Leeds

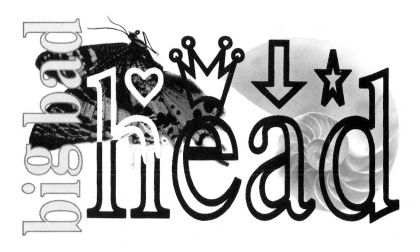

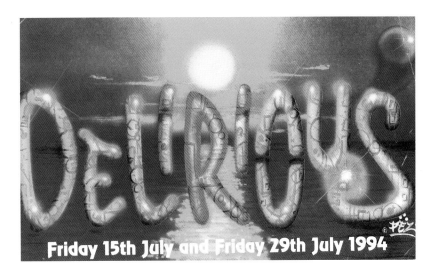

Big Bad Head
Date. 1991
Site. The Eclipse.
Coventry

Delirious
Design. Pez
Date. 1994
Site. Rhythm Station.
Aldershot

Andromeda 2
Date. 1991
Site. Ice Rink.
Telford

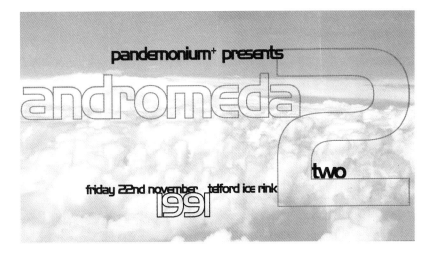

Flyers were absolutely vital to the success of the Haçienda. They rapidly became the way you communicated with people. We were the first club to look like a corporation and that was the legacy and the continuing involvement of our very design-orientated directors - particularly the fact that Peter Saville is still a consultant and that we had Trevor Johnson in his most creative period. Design is an extremely important part of what we are about and what we do.

Paul Mason The Haçienda **170895**

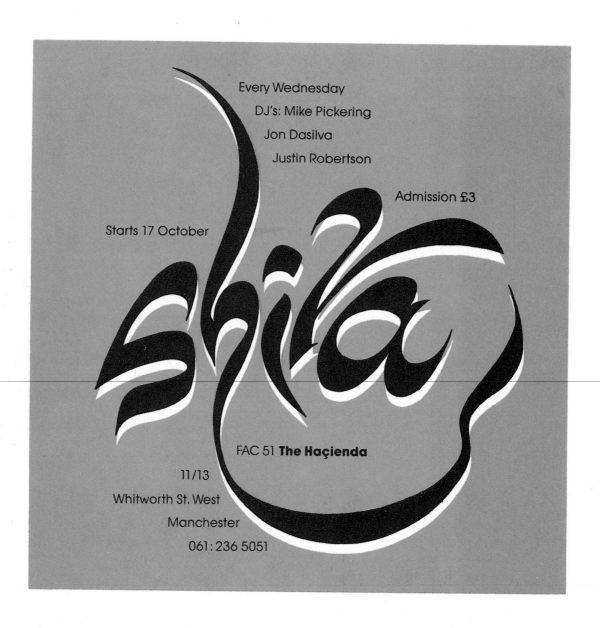

Every Wednesday
DJ's: Mike Pickering
Jon Dasilva
Justin Robertson

Admission £3

Starts 17 October

shiva

FAC 51 **The Haçienda**

11/13
Whitworth St. West
Manchester
061: 236 5051

Shiva
Design. Johnson Panas
Date. 1991
Site. The Haçienda.
Manchester

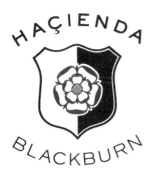

HAÇIENDA
BLACKBURN

STARTS TUESDAY 6TH FEBRUARY
MANHATTAN HEIGHTS
CICELY LANE
0254 60090

Haçienda Blackburn
Design. Johnson Panas
Date. 1991
Site. Manhattan Heights.
Blackburn

Zumbar
Design. Johnson Panas
Date. 1991
Site. The Haçienda.
Manchester

Wet
Design. Johnson Panas
Date. 1991
Site. The Victoria Baths.
Manchester

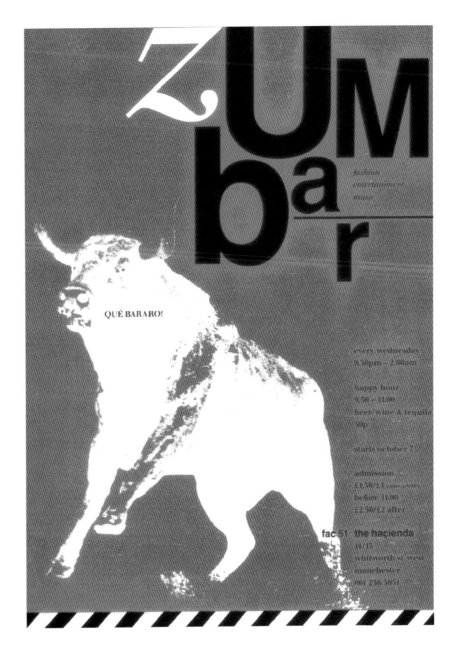

QUÉ BARARO!

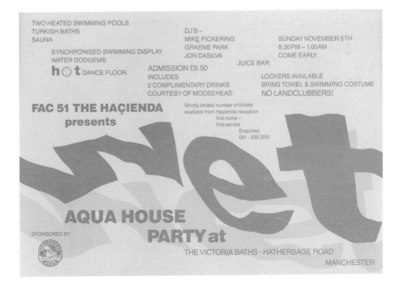

Everyone was completely off
their tits, myself included.
Ecstacy had arrived, everyone
was taking as much as they
possibly could and Mike
Pickering and I were playing the
best records around at the time.

Graeme Park *Mixmag* **010993**

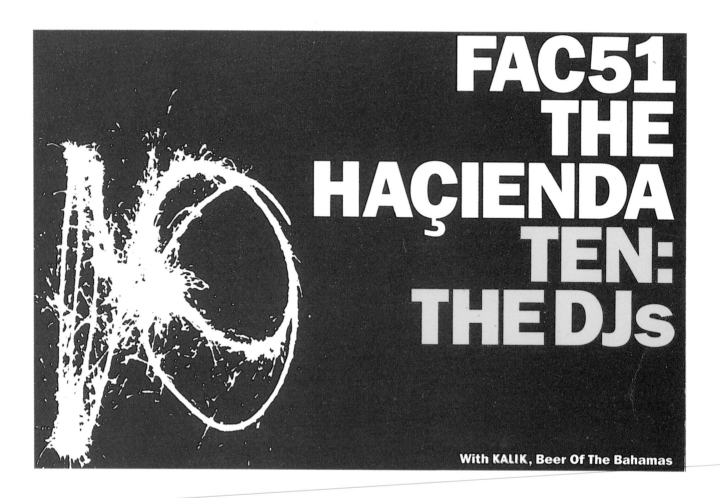

FAC51 THE HAÇIENDA TEN: THE DJs

With KALIK, Beer Of The Bahamas

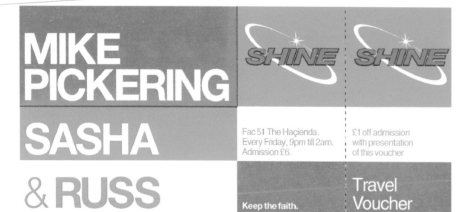

MIKE
PICKERING

SASHA

& RUSS

SHINE **SHINE**

Fac 51 The Haçienda.
Every Friday, 9pm till 2am.
Admission £6.

£1 off admission
with presentation
of this voucher

Keep the faith.

Travel
Voucher

Ten: The DJs
Design. John Macklin and Graeme Newman
Photography. Bernard Oglesby
Date. 1991
Site. The Haçienda.
Manchester

Shine
Design. Farrow
Date. 1993
Site. The Haçienda.
Manchester

The Shine logos were very much supposed to be corporate and the Cream logo was intended to
almost work as a corporate logo, I think it's the best way to approach things generally. My designs
are not fashion-based and the idea is that they don't date, they stay around. I'm still as happy with
the Shine logo today as the day I did it. The Cream logo has taken on a life of its own, they're kind
of branding it in the way that Nike would. I love it when you can take an idea to that stage, where
it's just a shape and everybody knows what it is.

Mark Farrow **180895**

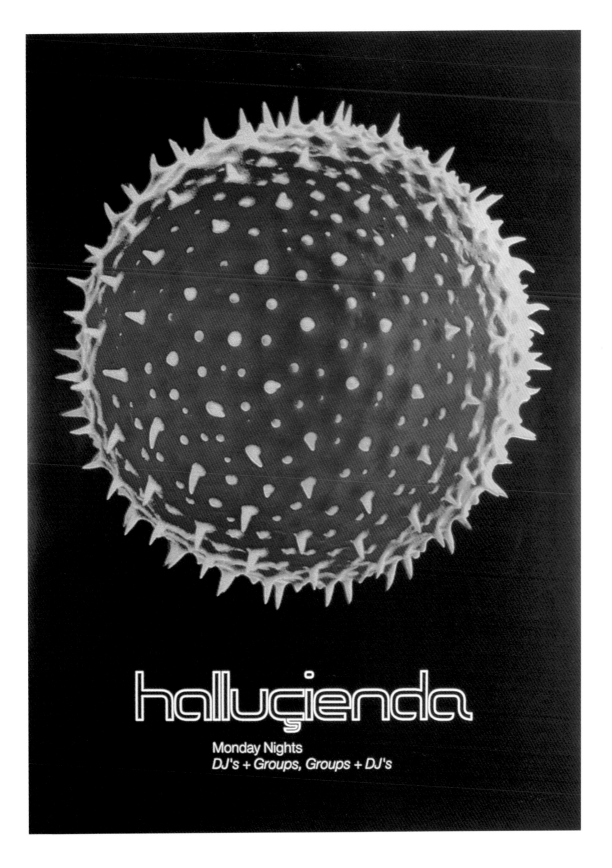

Halluçienda
Design. Peter Saville and Julian Morey
Photography. Anthony Burgess.
Science Photo Library
Date. 1989
Site. The Haçienda.
Manchester
poster

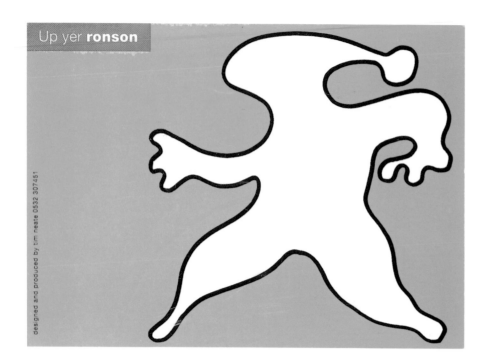

designed and produced by tim neate 0532 307451

Up yer **ronson**

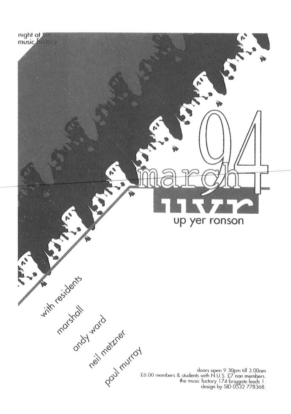

night at the
music factory

94
march
uvr
up yer ronson

with residents
marshall
andy ward
neil metzner
paul murray

doors open 9.30pm till 3.00am
£6.00 members & students with N.U.S. £7 non members.
the music factory 174 briggate leeds 1
design by SID 0532 778368.

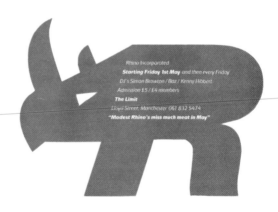

Rhino Incorporated
Starting Friday 1st May and then every Friday
DJ's Simon Browton / Baz / Kenny Hibbert
Admission £5 / £4 members
The Limit
Lloyd Street, Manchester 061 832 5474
"Modest Rhino's miss much meat in May"

Up Yer Ronson
Design. Tim Neate
Date. 1993
Site. The Music Factory.
Leeds
top

Design. Simon Lee
Date. 1994
Site. The Music Factory.
Leeds

Rhino Incorporated
Design. Craig Johnson
Date. 1994
Site. The Limit.
Manchester

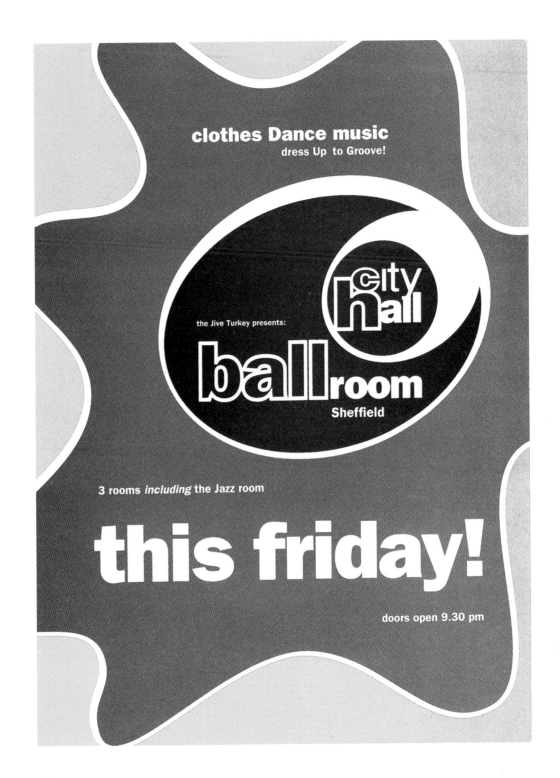

Ballroom
Design. The Designers Republic
Date. 1993
Site. City Hall Ballroom.
Sheffield

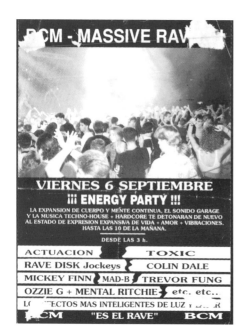

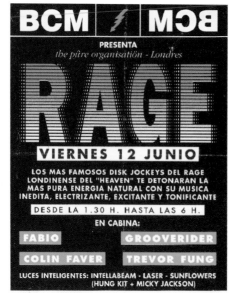

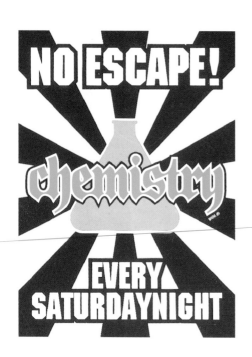

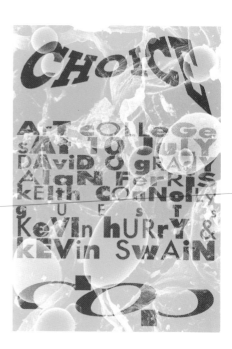

Massive Rave
Date. 1992
Site. BCM. Ibizia

Rage
Date. 1992
Site. BCM. Ibizia

Chemistry
Design. Shoe
Date. 1995
Site. E-Theatre.
Amsterdam

Choice
Date. 1992
Site. Art College.
Belfast

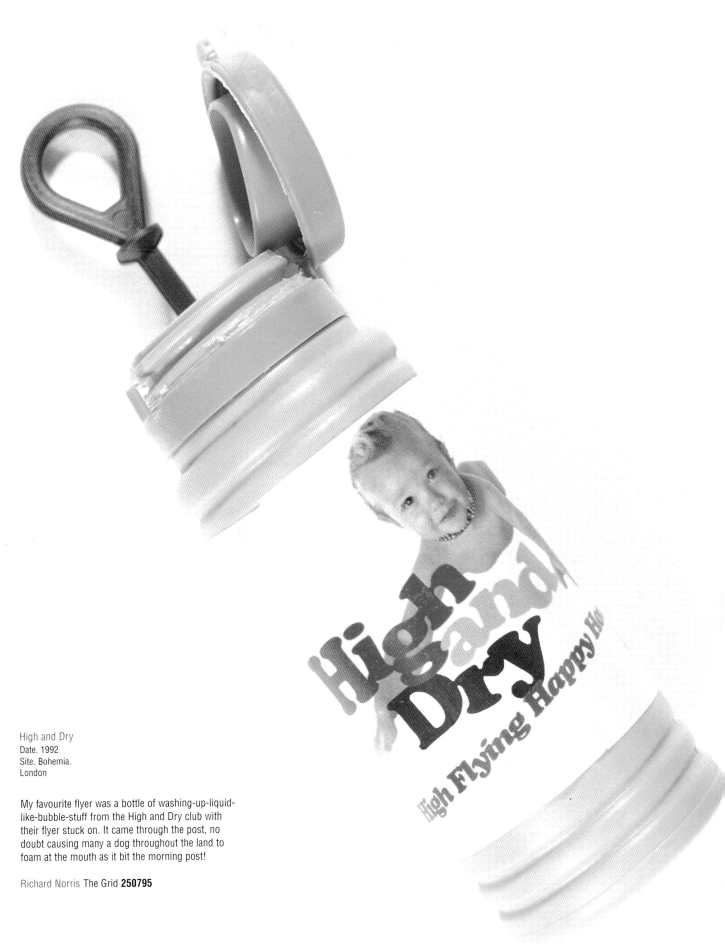

High and Dry
Date. 1992
Site. Bohemia.
London

My favourite flyer was a bottle of washing-up-liquid-like-bubble-stuff from the High and Dry club with their flyer stuck on. It came through the post, no doubt causing many a dog throughout the land to foam at the mouth as it bit the morning post!

Richard Norris The Grid **250795**

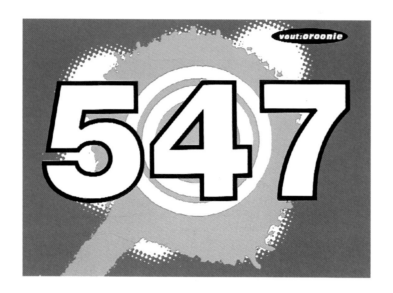

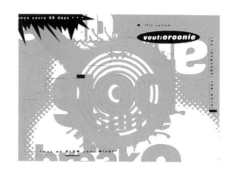

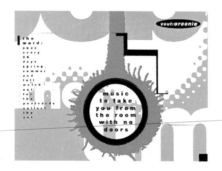

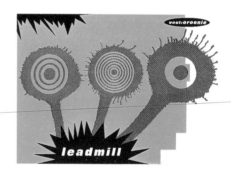

Vout:oroonie
Design. The Designers Republic
Date. 1992
Site. The Leadmill.
Sheffield

Universal
Design. Shed
Date. 1991
Site. 051.
Liverpool
unfolded

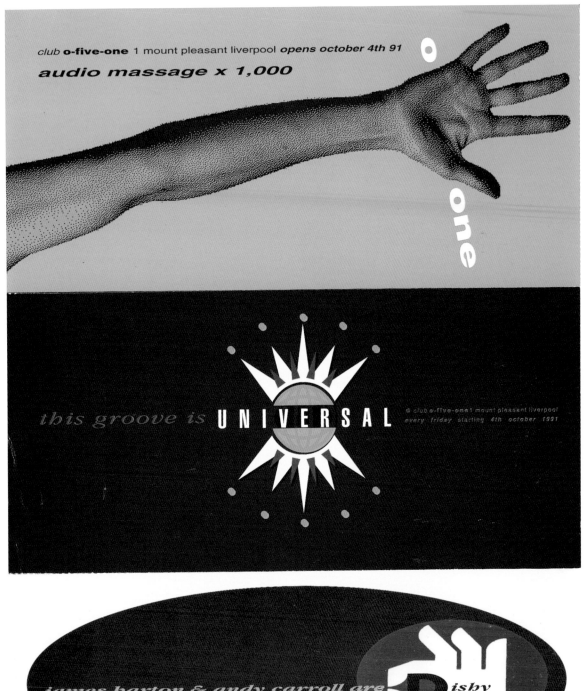

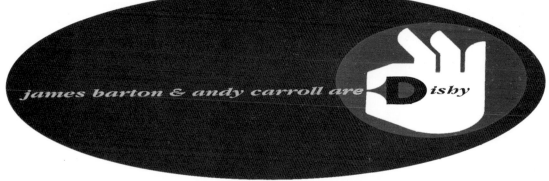

Saturdays. 02nd Pa by **HYPER GO GO**
(High, Never Let Go, Raise)*

09th **WELLY & MATT BELL**

16th **RETRO. Pa by MANIC**
(I'm Coming Hardcore)...a night of club classics*

23rd **CARL COX** Plays House

30th Pa by **TC 91.92.93.94**
Direct from Italy (Berry, Harmony, Funky Guitar)*

Angels resident dj's are: Paul Taylor, Fresh & Rick B

Admission: £6 members. £8 non members *Admission £7 members, £9 non members
Angels. PO Box 68 Curzon Street, Burnley, Lancashire BB11 1BX. M65 exit junction 10, in town
centre (next to M&S) tel: 0282 35222 /0836 544661. Over 18's only - ID required - Dress code

Membership is free. Send this slip to us, enclosing a S.A.E. for guaranteed reduced admission. Are you interested
in organising a coach party from your area at reduced rates ? If so, give us a call and we will organise it for you

name d.o.b

address / postcode

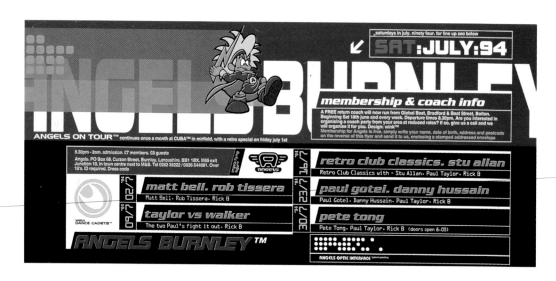

.saturdays in july. ninety four. for line up see below
SAT:JULY:94

ANGELS ON TOUR™ continues once a month at CUBA™ in mirfield. with a retro special on friday july 1st

membership & coach info
A FREE return coach will now run from Global Beat, Bradford & Beat Street, Bolton.
Beginning Sat 18th June and every week. Departure times 8.30pm. Are you interested in
organising a coach party from your area at reduced rates? If so, give us a call and we
will organise it for you. Design: wink™
Membership for Angels is free, simply write your name, date of birth, address and postcode
on the reverse of this flyer and send it to us, enclosing a stamped addressed envelope

8.30pm - 2am. admission. £7 members. £8 guests
Angels. PO Box 68. Curzon Street, Burnley, Lancashire, BB1 1BX. M&S exit
Junction 10. In town centre next to M&S. Tel 0282 35222 / 0836 544661. Over
18's. ID required. Dress code

16/7 **retro club classics. stu allan**
Retro Club Classics with - Stu Allan - Paul Taylor - Rick B

02/7 **matt bell. rob tissera**
Matt Bell - Rob Tissera - Rick B

23/7 **paul gotel. danny hussain**
Paul Gotel - Danny Hussain - Paul Taylor - Rick B

09/7 **taylor vs walker**
The two Paul's fight it out. Rick B

30/7 **pete tong**
Pete Tong - Paul Taylor - Rick B (doors open 8.00)

ANGELS DANCE CADETS™

ANGELS BURNLEY™

ANGELS OPTIC INTERFACE patent pending

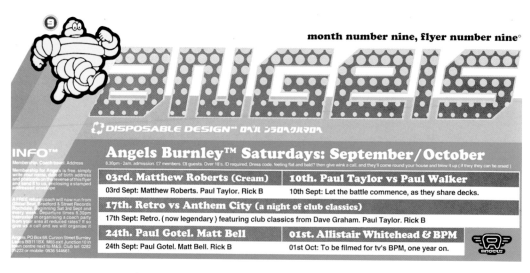

month number nine, flyer number nine°

ANGELS

DISPOSABLE DESIGN™

Angels Burnley™ Saturdays: September/October
8.30pm - 2am. admission: £7 members. £8 guests. Over 18's. ID required. Dress code. feeling flat and bald? then give wink a call, and they'll come round your house and blow it up (if they can be arsed)

INFO™
Membership. Coach travel. Address

Membership for Angels is free, simply
write your name, date of birth address
and postcode on the reverse of this flyer
and send it to us, enclosing a stamped
addressed envelope

A FREE return coach will now run from
Global Beat, Bradford & Street Records
Rochdale. Beginning Sat 3rd Sept and
every week. Departure times 8.30pm
interested in organising a coach party
from your area at reduced rates? If so
give us a call and we will organise it

Angels. PO Box 68. Curzon Street Burnley
Lancs BB11 1BX. M65 exit Junction 10 in
town centre next to M&S. Club tel: 0282
35222 or mobile: 0836 544661.

03rd. Matthew Roberts (Cream)	10th. Paul Taylor vs Paul Walker
03rd Sept: Matthew Roberts. Paul Taylor. Rick B	10th Sept: Let the battle commence, as they share decks.
17th. Retro vs Anthem City (a night of club classics)	
17th Sept: Retro. (now legendary) featuring club classics from Dave Graham. Paul Taylor. Rick B	
24th. Paul Gotel. Matt Bell	01st. Allistair Whitehead & BPM
24th Sept: Paul Gotel. Matt Bell. Rick B	01st Oct: To be filmed for tv's BPM, one year on.

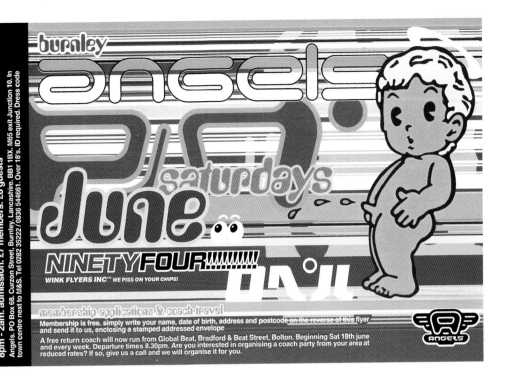

Angels
Design. Wink Associates
Date. 1994
Site. Angels.
Burnley

Shindig
Design. Slump
Date. 1995
Site. Riverside.
Newcastle

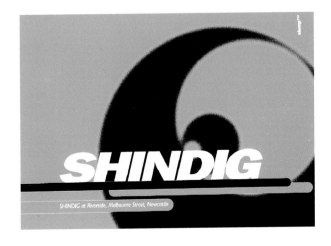

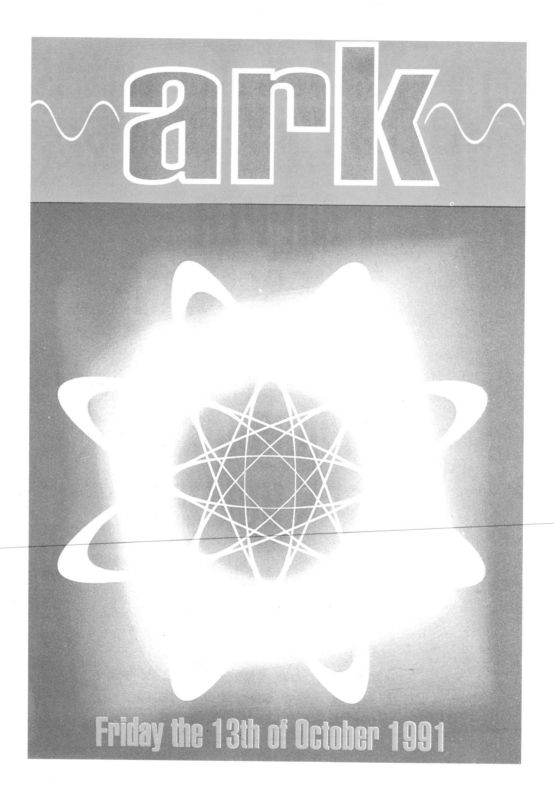

ark

Friday the 13th of October 1991

Big ones, small ones, fat ones and thin ones. Glow in the dark ones and blatent copies. Rude ones, cheeky ones, sticky ones and witty ones. The thousand times we heard "summit ta wipe me arse wit" or "gis one for mi mate", made it all worthwile. They've brought down governments, been admired by kings, you either love em or hate em! Personally I never leave home without one. Keep em coming!

Rob Tyrell Ark **170895**

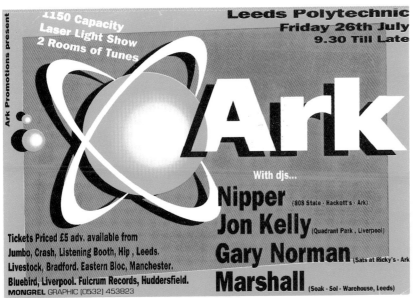

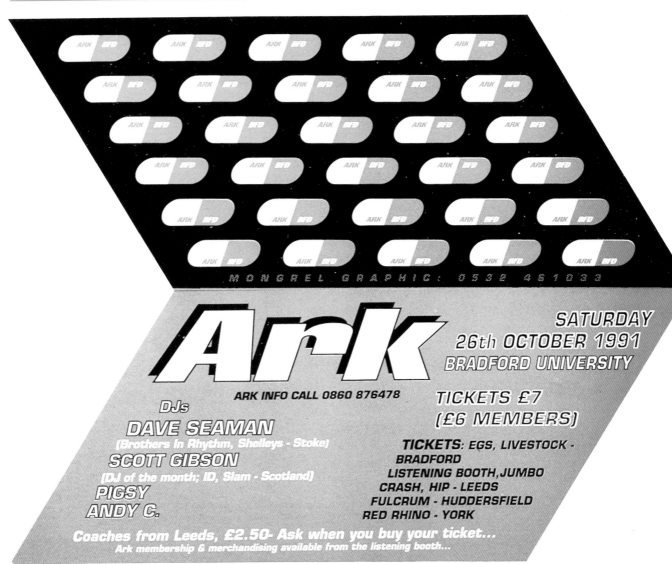

Ark
Design. Mongrel Graphic
Date. 1991
Sites. Leeds Polytechnic. Leeds
Bradford University. Bradford

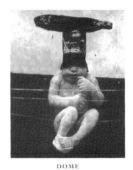

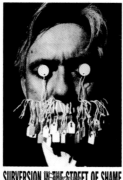

DOME

Disobey

THURSDAY 1 DECEMBER 1994

SUBVERSION IN THE STREET OF SHAME

THURSDAY **14** FRIDAY **15** SATURDAY **16** JULY **1994**

BRIDEWELL THEATRE, BRIDE LANE, LONDON EC4

RUDOLPH GREY / CHARLES GAYLE / TOM SURGAL
AS
THE BLUE HUMANS

Disobey

THURSDAY 28 JULY 1994

KEIJI HAINO

Disobey

THURSDAY 27 OCTOBER 1994

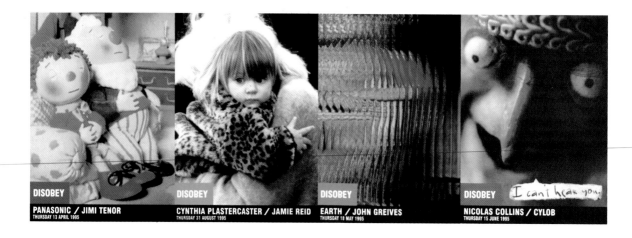

DISOBEY

PANASONIC / JIMI TENOR
THURSDAY 13 APRIL 1995

DISOBEY

CYNTHIA PLASTERCASTER / JAMIE REID
THURSDAY 31 AUGUST 1995

DISOBEY

EARTH / JOHN GREIVES
THURSDAY 18 MAY 1995

DISOBEY I can't hear you.

NICOLAS COLLINS / CYLOB
THURSDAY 15 JUNE 1995

Disobey

Counting Lessons In Purgatory
by Joel-Peter Witkin
Date. 1994
Site. The Garage. London

Subversion In The Street Of Shame
Photography. Paddy Summerfield
Date. 1994
Site. Bridewell Theatre. London

Gift Wrapped Doll No.16
by James Rosenquist
Date. 1994
Site. The Garage. London

Goat
by Stuart Colwill
Date. 1994
Site. The Garage. London

Longtime Companion
by Mr Plod
Date. 1995
Site. The Garage. London

Frances Bean
by James Rexroad
Date. 1995
Site. The Garage. London

Zur Erinnerung An Lidice
by Jiri Kolar
Date. 1995
Site. The Garage. London

Mr Punch
by Dave McKean
Date. 1995
Site. The Garage. London

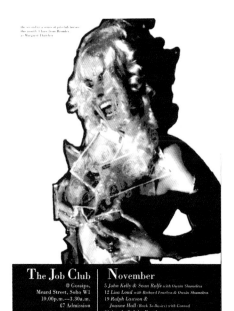

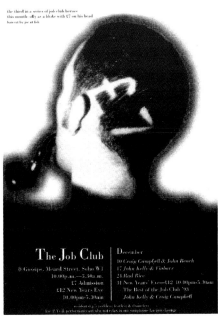

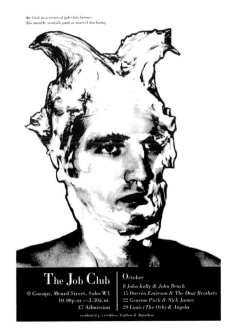

The Job Club
Design. Simon Taylor at Tomato
Date. 1994
Site. Gossips. London

HARD TIMES

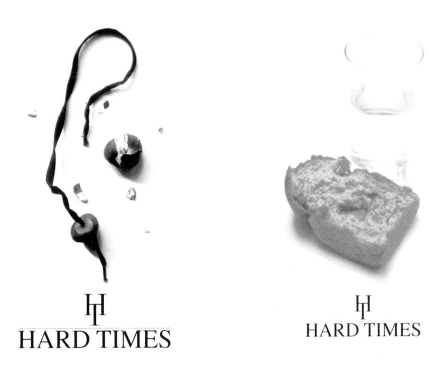

HARD TIMES

HARD TIMES

Hard Times
Design. Paul Cleary
Photography. Paul Cleary
Date. 1994
Site. 106 Huddersfield Road.
Mirfield

The name Hard Times was chosen because it
reflected the personal situation of everyone
involved in the setting up of the club: struggling
financially, stuck in dead-end jobs or unemployed.
At that time, everyone else's flyers were all bright
colours and flashing lights. We wanted each flyer
to make an individual statement.

Steve Raine Hard Times **180895**

Ministry of Sound
Design. Thomas & Thomas
Photography. Thomas & Thomas
Date. 1994-1995
Site. Ministry of Sound.
London

I think Ministry Of Sound has effectively branded it's image onto their flyers. Our Rulin' flyer took very boring people and glammed them up - this is our image. I especially liked the Margaret Thatcher flyer, it made her look like a woman and was very clever.

Lynn Cosgrave Ministry Of Sound **030895**

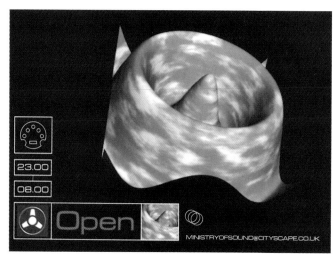

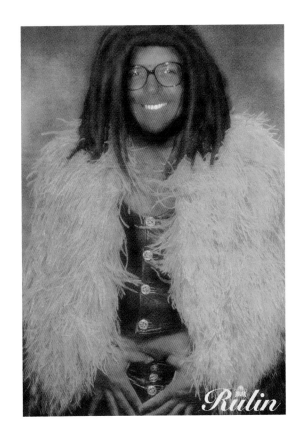

Rulin

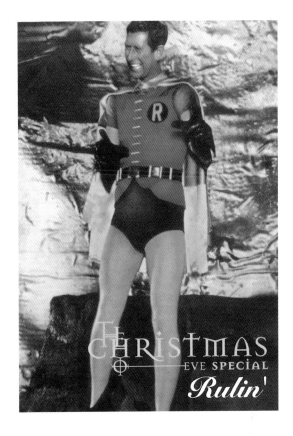

CHRISTMAS
EVE SPECIAL

Rulin'

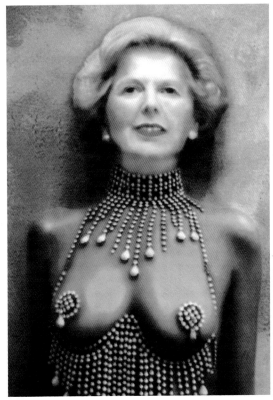

Rulin

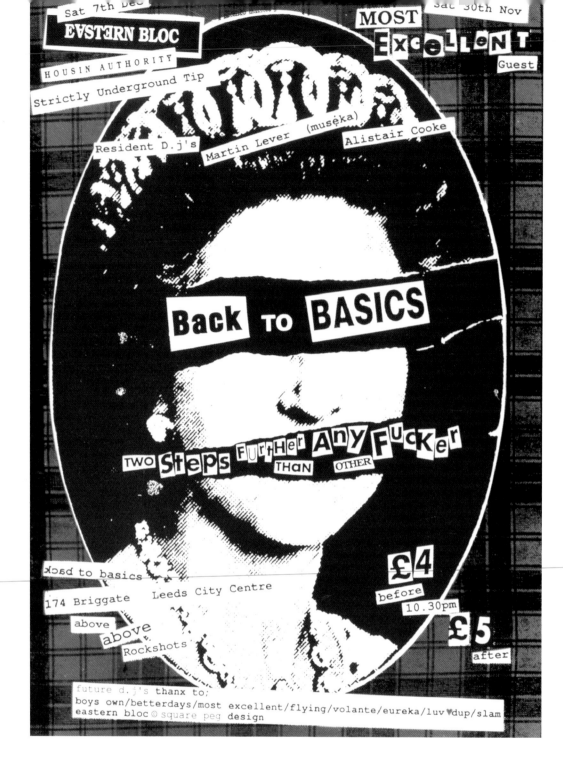

We started Back to Basics as a backlash against the otherwise jaded dance scene. We were sick and tired of half-dressed half-wits, running around blowin' whistles and pulling faces with promoters who had no respect for the punters. Most flyers of this period reflected Ecstasy, sunshine, love and euphoric images. It was becoming a right old load of bollocks and something had to be done. As myself and Allister grew up through the 70s and were severely influenced by the punk explosion it just seemed like a natural progression to utilise the images and attitudes of that period. After all, Acid House had many things in common with Punk, with the lawlessness of the illegal raves and the great influence it had on youth culture going back into the clubs. When we first used the Queen's head - which Jamie Reid has kindly let us adopt - on our second flyer it had a great impact and attracted people from all over the country, who were also tired of the apathy surrounding the House scene at the time. This gave us scope to be naughty, cheeky and as outrageous as we wanted - after all the imagery on the flyer should show the essence of the club.

Dave Beer Back to Basics **180895**

Back To Basics
Original concept. Jamie Reid
Design. SquarePeg:Design
Date. 1993
Site. Back to Basics.
Leeds

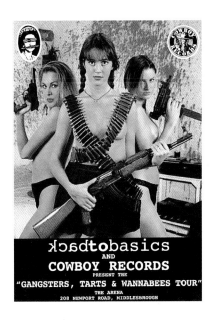

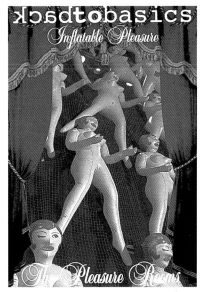

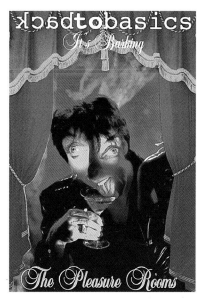

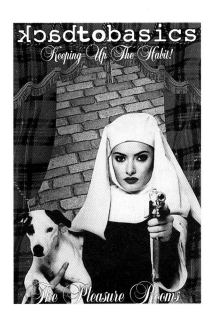

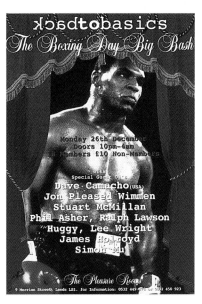

Back To Basics
Design. AR:5E and Dave Beer
Date. 1994-1995
Site. Pleasure Rooms.
Leeds

Biology Design. Damon Date. 1993 Site. Houslow Ravedome. DESERT STORM & THE TEAM B BIOLOGY

Illustrious Date. 1991 Site. Nelson Mandella Building. Sheffield

Oranges Don't Dance Date. 1990 Site. The Astoria. London
ORANGES DON'T DANCE

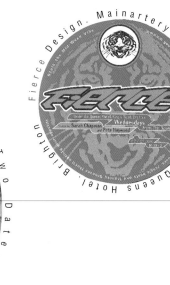

The World Design. Craig Johnson Date. 1994 Site. Home. Manchester
·THE· ·WORLD·

The Boogie Zone Date. 1993 Site. Rockerderos. Nottingham
Enjoy The Boogie Zone
REGISTERED TRADE MARK

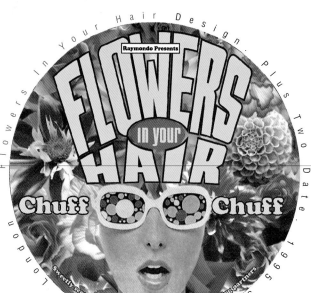

Flowers In Your Hair Design. Plus Two Date. 1995 Site. Chuff Chuff. London
Raymondo Presents
FLOWERS in your HAIR
Chuff Chuff
Sweetly scented flowers are such loyal and undemanding partners

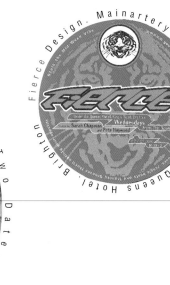

Fierce Design. Mainartery Date. 1994 Site. The Queens Hotel. Brighton
FIERCE

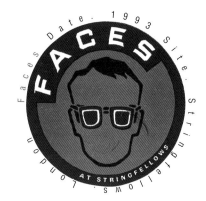

Faces Date. 1993 Site. Stringfellows. London
FACES
AT STRINGFELLOWS

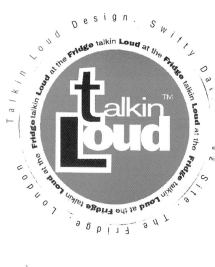

Talkin Loud Design. Swifty Date. Site. The Fridge. London
talkin Loud at the Fridge talkin Loud at the Fridge talkin Loud at the Fridge talkin Loud at the Fridge talkin Loud at the Fridge talkin Loud at the Fridge talkin Loud at the Fridge
talkin Loud ™

Hello Date. 1995 Site. Flamingo Bar. London
HELLO
33 2

Devil May Care Date. 1990 Site. The Academy. Uxbridge
DEVIL MAY CARE

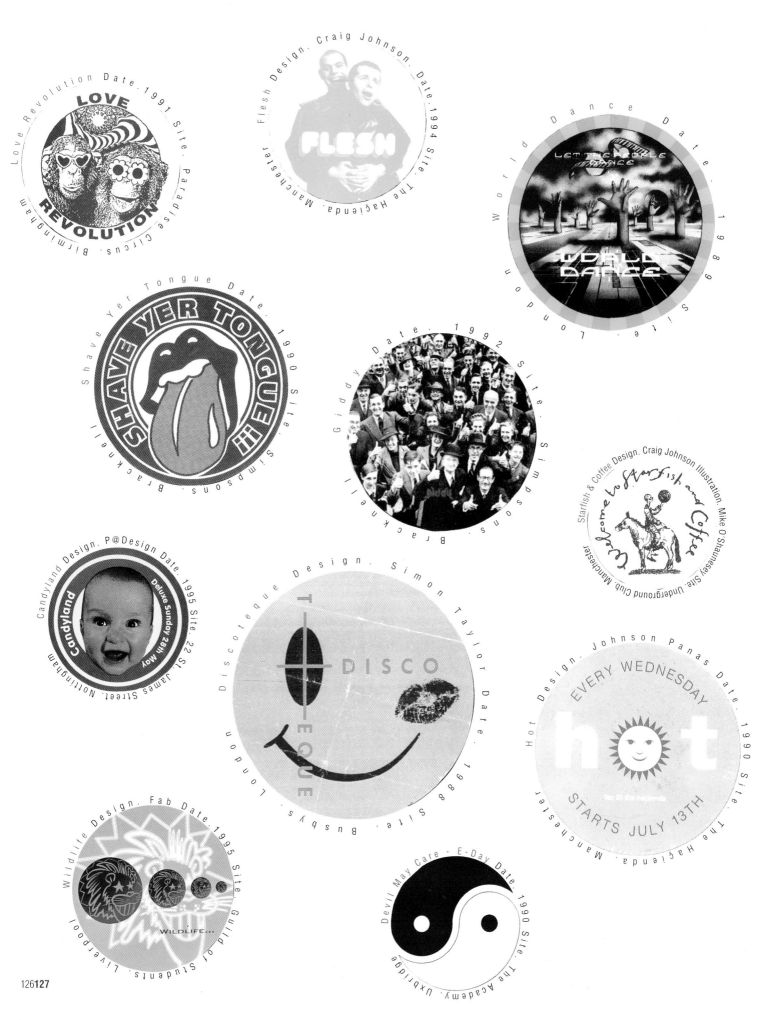

Love Revolution Date. 1991 Site. Paradise Circus. Birmingham

LOVE REVOLUTION

Flesh Design. Craig Johnson. Date. 1994 Site. The Hacienda. Manchester

FLESH

World Dance Date. 1989 Site. London

LET THE WORLD DANCE

WORLD DANCE

Shave Yer Tongue Date. 1990 Site. Simpsons. Bracknell

SHAVE YER TONGUE!!!

Giddy Date. 1992 Site. Simpsons. Bracknell

Starfish & Coffee Design. Craig Johnson Illustration. Mike O'Shaunessey Site. Underground Club. Manchester

Welcome to Starfish and Coffee

Candyland Design. P@Design Date. 1995 Site. 22 St. James Street. Nottingham

Candyland
Deluxe Sunday 28th May

Discoteque Design. Simon Taylor Date. 1988 Site. Busbys. London

DISCO TEQUE

Hot Design. Johnson Panas Date. 1990 Site. The Hacienda. Manchester

EVERY WEDNESDAY
hot
STARTS JULY 13TH

Wildlife Design. Fab Date. 1995 Site. Guild of Students. Liverpool

WILDLIFE...

Devil May Care - E-Day Date. 1990 Site. The Academy. Uxbridge

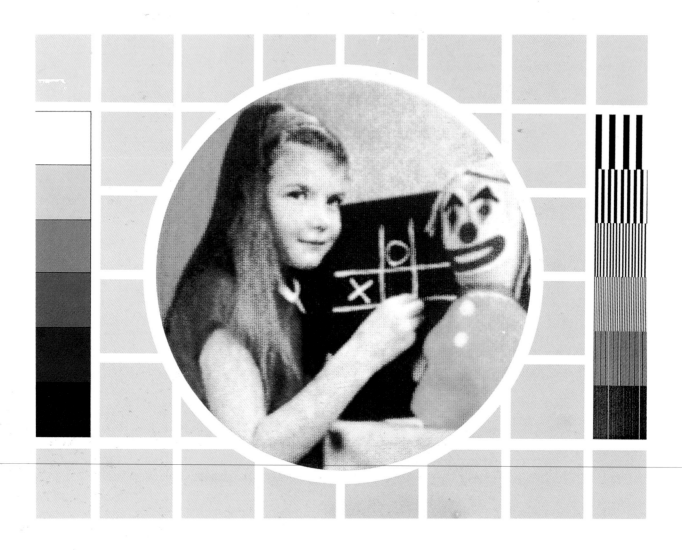

Heaven
Design. Richie Aspinall
Date. 1993
Sites. The Millionaires. Manchester
Fallows 2. Liverpool

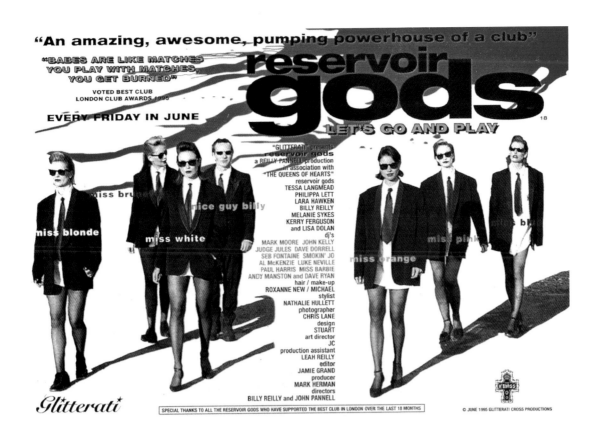

Glitterati
Design. Jonathan Cuttings
Date. 1995
Site. The Cross.
London

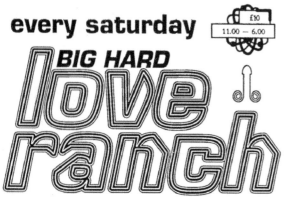

every saturday

£10
11.00 – 6.00

BIG HARD
love ranch

Nov 16 Paul Oakenfold

Live Ether Real

Nov 23 Kevin Hurry

Live Baby June

Nov 30 Lisa Loud

Live IF?

plus residential DJ's Al Mackenzie Rad Rice
Peace in What Fucking Valley?

11.00 – 6.00
Maximus
14 Leicester Square

Love Ranch
Date. 1991
Site. Maximus.
London

Dreamscape
Date. 1989
Site. Village Complex.
London

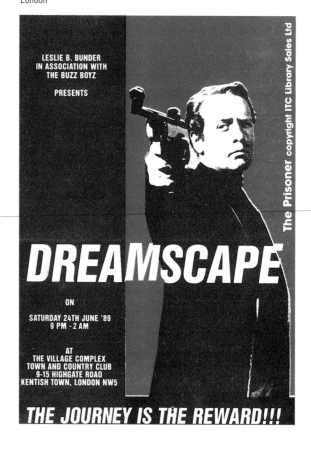

LESLIE B. BUNDER
IN ASSOCIATION WITH
THE BUZZ BOYZ

PRESENTS

DREAMSCAPE

ON

SATURDAY 24TH JUNE '89
9 PM - 2 AM

AT
THE VILLAGE COMPLEX
TOWN AND COUNTRY CLUB
9-15 HIGHGATE ROAD
KENTISH TOWN, LONDON NW5

The Prisoner copyright ITC Library Sales Ltd

THE JOURNEY IS THE REWARD!!!

Through The Looking Glass
Date. 1994
Site. Venue 44.
Mansfield

Eat Me!
Date. 1986
Site. Legends.
London

The Pussy Posse Presents...

PAMELA PAMPER

On Sunday 26th April

7.00 pm Prompt

"There's nothing Pamela enjoys more than a full steam and massage with her friends; especially when her favorite tunes are playing.

Her nails always need manicuring and her lovely locks dressed; because Pamela works her fingers to the bone and can often be seen dragged through a bush backwards. But when she's not snogging her favorite 'boys' in town, she loves to relax, stuff her face, feel it go pink in the heat, and appreciate herself."

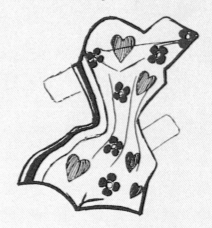

GLUE HERE

CUT ALONG LINE

PP

Tickets in advance:

from Farika DNA – 071 287 4126

Sara B – 071 821 6529

Tiggy – 071 229 2829

Come Pamper Yourself with Pamela

At: The Porchester Spa, Porchester Road, W2 Dress Bare as you Dare Birds Only

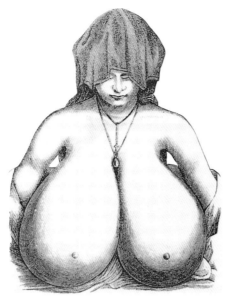

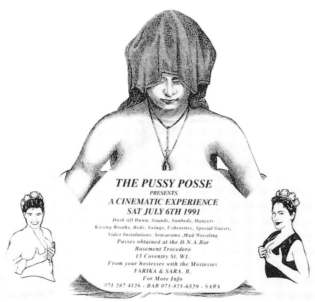

Pussy Posse

Pamela Pamper
Concept. Sara Blonstein and Farika Skilton
Design. David Little
Date. 1990
Site. Porchester Spa.
London

A Cinematic Experience
Concept. Sara Blonstein and Farika Skilton
Design. David Little
Date. 1991
Site. DNA Bar.
London
folded and unfolded

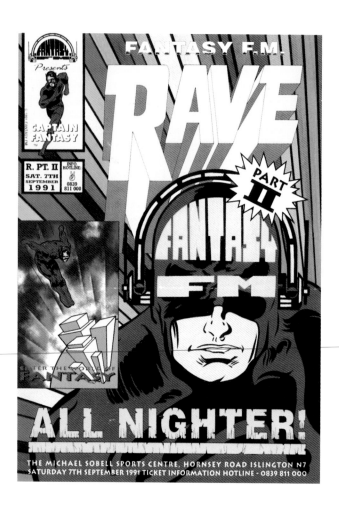

Rave Part 2
Design. Fantasy FM
Date. 1991
Site. Michael Sobell Sports Centre
London

Bugged Out!
Design. Jockey Slut
Date. 1995
Site. Sankeys Soap.
Manchester

The Ark
Design. Duncan Reed
Date. 1994
Site. The Tunnel.
Glasgow

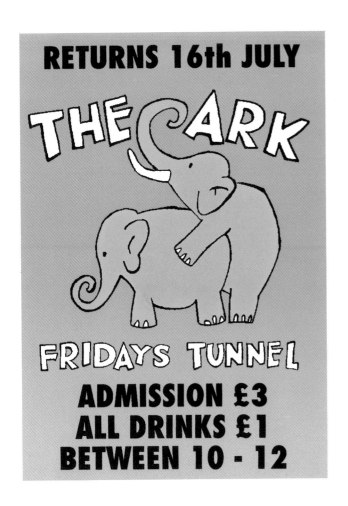

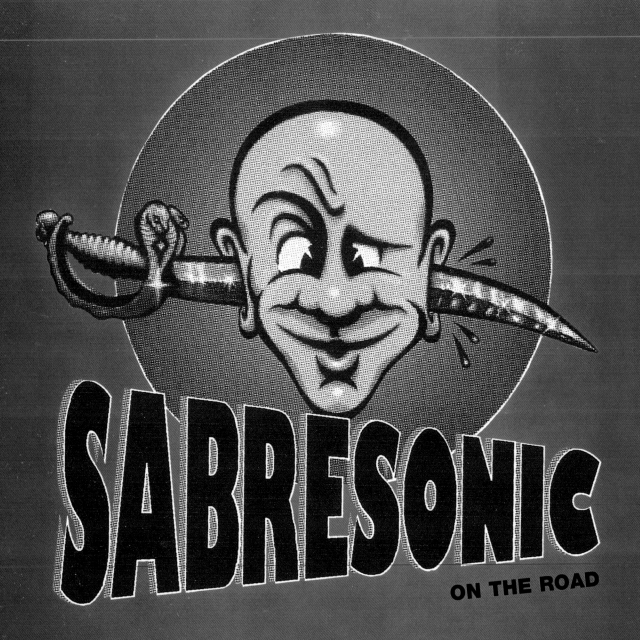

SABRESONIC
ON THE ROAD

THE SABRES OF PARADISE
ANDREW WEATHERALL & ALEX KNIGHT
VISUALS BY VEGETABLE VISION

Thursday 19th May 9pm–3am
London SW1 Club £9.00

THE ALBUM 'SABRESONIC' WILL BE DELETED 31ST MAY 1994.

This date has a no jugglers, no fire eaters, no flutes & no hippy's with lawyers policy. Anyone found with concealed batons, juggling balls or recorders will be removed from the venue. You have been warned!

My favourite flyer has nothing to do with Acid House, but was
for a one-man theatre production in Galway. It simply said
"Unloved lonely men with animals in their underpants".
As far as Acid House goes, the ones with shit O-Level artwork
and pseudo-intellectual cobblers about the meaning of life
through dance (with misprints) are special favourites.

Andrew Weatherall **200795**

Sabresonic
Design. Madark
Date. 1994
Site. SW1 Club.
London

Rise
Design. Vivid Design Factory
Illustration. Rob Richardson
Date. 1995
Site. The Leadmill.
Sheffield

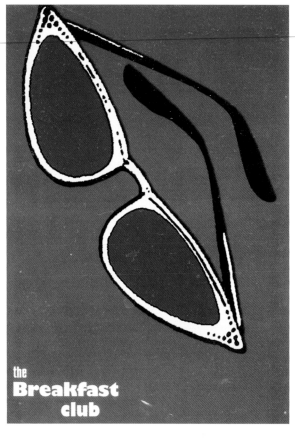

Beautiful 2000
Design. Knopov
Date. 1993
Site. The Haçienda.
Manchester

A Toaster A Blender And A 6ft Fish
Design. Naked
Date. 1994
Site. Corn Exchange.
Leeds

The Breakfast Club
Design. Mongrel Graphic
Date. 1992
Site. Leeds Polytechnic.
Leeds

SAWNOFF PRODUCTIONS TERRORIZE THE EARTH WITH

THE GIANT ICON FROM OUTER SPACE

You Won't
Believe Your
Eyes But- You'll
Never Forget
What They See!

Rimini comes to Icon

Icon
Design. Sawnoff
Date. 1992
Site. 051.
Liverpool

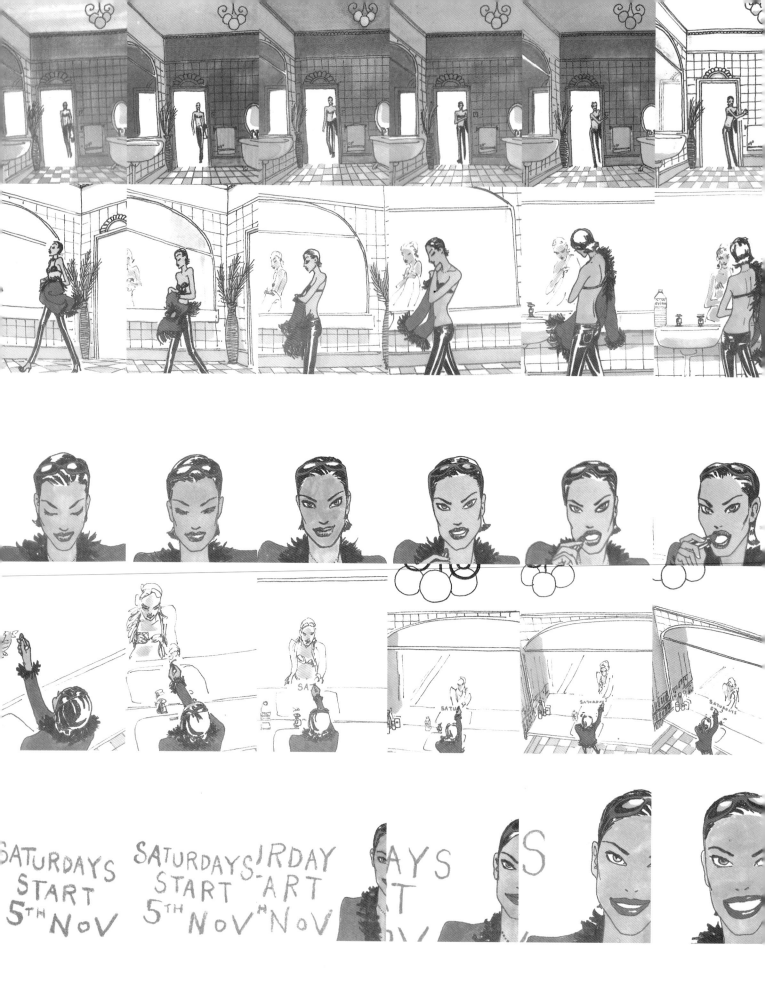

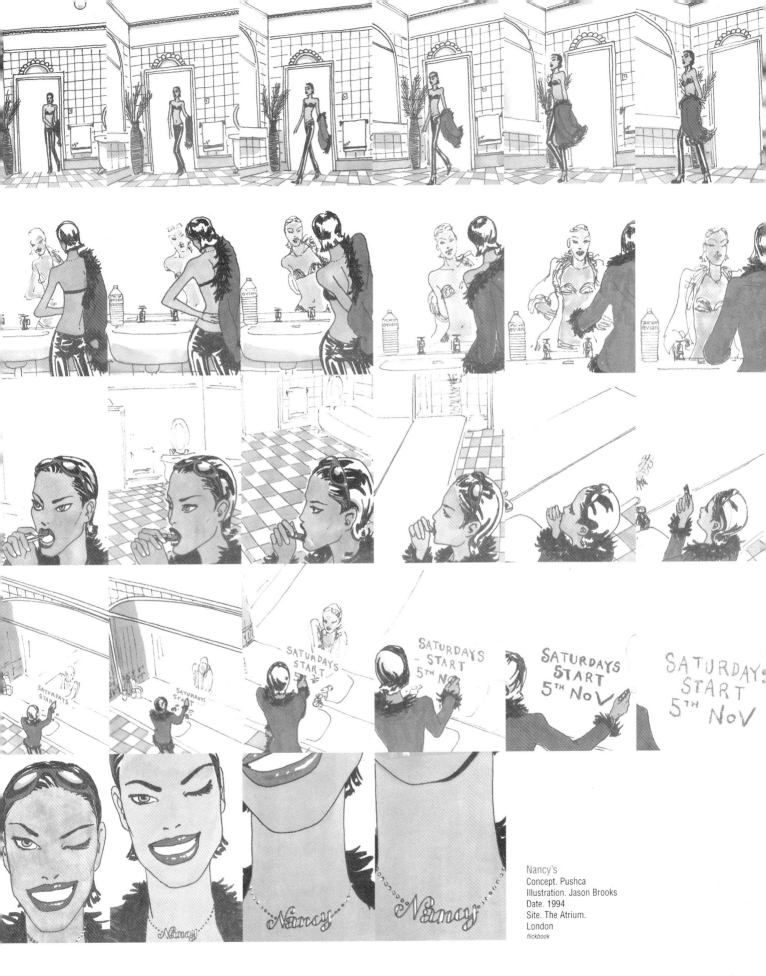

Nancy's
Concept. Pushca
Illustration. Jason Brooks
Date. 1994
Site. The Atrium.
London
flickbook

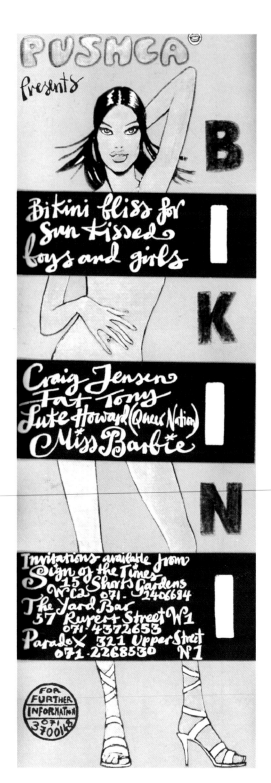

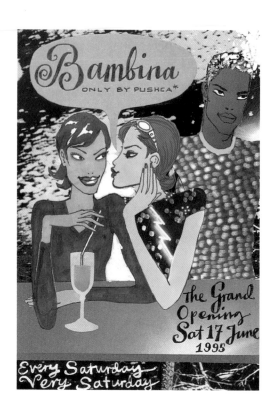

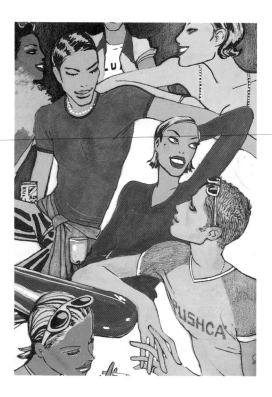

Pushca presents Bikini
Design. Pushca
Illustration. Jason Brooks
Date. 1994
Site. Holborn Studios.
London

Bambina
Illustration. Jason Brooks
Date. 1995
Site. Venom.
London

Love To Lounge
Illustration. Jason Brooks
Date. 1994
Site. Holborn Studios.
London

Camp It Up
Design. Simon Chalmers and Russell Hall
Date. 1994
Site. Black Island Film Studios.
London

Baby Doll
Design. Simon Chalmers and Russell Hall
Date. 1994
Site. Gainsborough Studios.
London

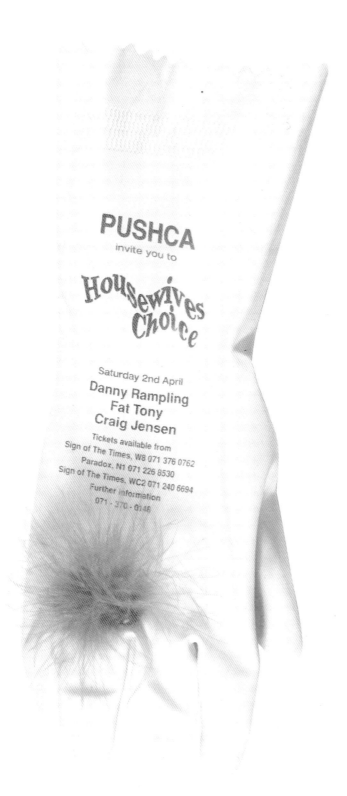

Summer by Pushca
Design. Simon Chalmers and Russell Hall
Date. 1994
Site. London

Housewives Choice
Concept. Pushca
Design. Simon Chalmers and Russell Hall
Date. 1994
Site. Ealing Film Studios.
London

WESTWORLD FIVE
GOTHAM CITY

Saturday July 4
Members only — Advance tickets $6
From Westworld Wash,
201 Kings Road, SW3.

 Westworld 6 SIX6
WitchWorld
HEAVYWEIGHT HALLOWEEN GHOSTBUSTING MONSTER MASH
ALL NEW – ALL TOGETHER – TERROR TWISTER – ROLLER CHAMBER – BUCKING BROOMSTICK – FEARSOME FILMS – DEMON DANCEFLOOR

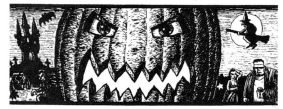

SATURDAY OCTOBER 31 TICKETS 7 HOUNDS THE HAUNTED CASTLE
TOME OPENS 9pm MEMBERS & THEIR GUESTS ONLY 211 STOCKWELL RD
BAR CLOSES 1am ADVANCE TICKETS FROM KINGS TICKET AGENCY LONDON SW9
 c/o Chelsea Wash Inn, 201 Kings Rd, SW3, Mon – Sat 10 – 7
WESTWORLD RESERVE RIGHT OF ADMISSION. NO WEREWOLVES.

Westworld Productions Present
WET WORLD
EARLY EVENING SWIM 'N' SURF POOLSIDE PARTY
WILD WAVEMAKER – DINGHY DODGEMS – SERIOUS SAUNAS – THREE HEATED POOLS – DECKSIDE DANCEFLOOR – CHUTE TO CHILL

BRING SWIMSUIT AND TOWEL AND SENSE OF HUMOUR LOCKERS AVAILABLE LICENSED BAR

S U R F ' S U P DELUXE RESTRICTED NUMBERS EVENT W E T W O R L D
FRIDAY OCTOBER 2 TICKETS £8 WITH WESTWORLD MEMBERSHIP CARD THE FULHAM POOLS
8.30 – 1am plug out 300 TICKETS ONLY – FIRST COME FIRST SURFED Normand Park
 Kings Ticket Agency c/o Chelsea Wash Inn Lillie Road
COME EARLY 201 Kings Rd, SW3 – Sat Sept 19, Sat Sept 26, Fri Oct 2 Fulham SW6

WESTWORLD RESERVE RIGHT OF ADMISSION

Westworld Productions Present
WET WORLD II . . JAWS
EARLY EVENING SWIM 'N' SURF POOLSIDE PARTY
WILD WAVEMAKER – DINGHY DODGEMS – SERIOUS SAUNAS – THREE HEATED POOLS – DECKSIDE DANCEFLOOR – CHUTE TO CHILL

SWIMSUIT AND TOWEL AND SENSE OF HUMOUR ESSENTIAL LOCKERS AVAILABLE LICENSED BAR

S U R F ' S U P DELUXE RESTRICTED NUMBERS EVENT W E T W O R L D
SATURDAY OCTOBER 17 TICKETS £8 WITH WESTWORLD MEMBERSHIP CARD THE FULHAM POOLS
8.30 – 1am plug out 300 TICKETS ONLY – FIRST COME FIRST SURFED Normand Park
 Kings Ticket Agency c/o Chelsea Wash Inn Lillie Road
COME EARLY 201 Kings Rd, SW3 – Sat Oct 10, Sat Oct 17, 10am-7pm Fulham SW6

253 0075 FOR INFO & TICKET RESERVATIONS WESTWORLD RESERVE RIGHT OF ADMISSION

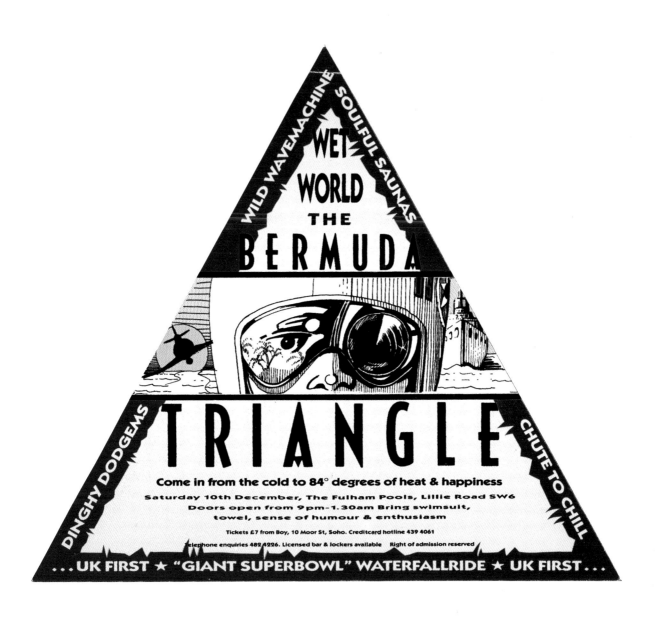

Westworld
Date. 1986
Site. Brixton Acdemy.
London

Wetworld
Date. 1987
Site. Fulham Pools.
London

For me the most original venue was for Wetworld's Bermuda Triangle at Fulham Pools, an idea revived by Boys Own at Bognor Regis. The success of the Boys Own parties proved that you don't need to hand out 50,000 flyers at someone else's parties to put on large events. Word of mouth is just as good as a flyer. If your audience knows what your events are like, why tell everyone else?

Andy Martin Fatcat Records **250795**

FRIDAY 13th/SATURDAY 14th AUGUST 1993
12AM (NOON) - 9AM (AND BEYOND) - MAIN STAGES 7PM - 9AM
LOWER PERTWOOD FARM, A350. NR. WARMINSTER, WILTSHIRE UK.
30,000 HEARTS CONVERGE FOR A 24 HR FESTIVAL OF THE FUTURE - THE LAST UNIVERSE UK PARTY OF '93

Universe
Date. 1991
Site. A46. Avon
unfolded
opposite

Big Love
Date. 1993
Site. Lower Pertwood Farm.
Wiltshire

In The Underworld
Date. 1992
Site. Westpoint Exhibition Centre.
Devon

Pleasure Planet
Date. 1992
Site. Newport

The Final Frontier
Design. Rob Janes
Date. 1994
Site. Club UK.
London

Illustration. Amanda Delf
except for March flyer featuring
"The Red Road Leads Home"
by Patricia Wyatt

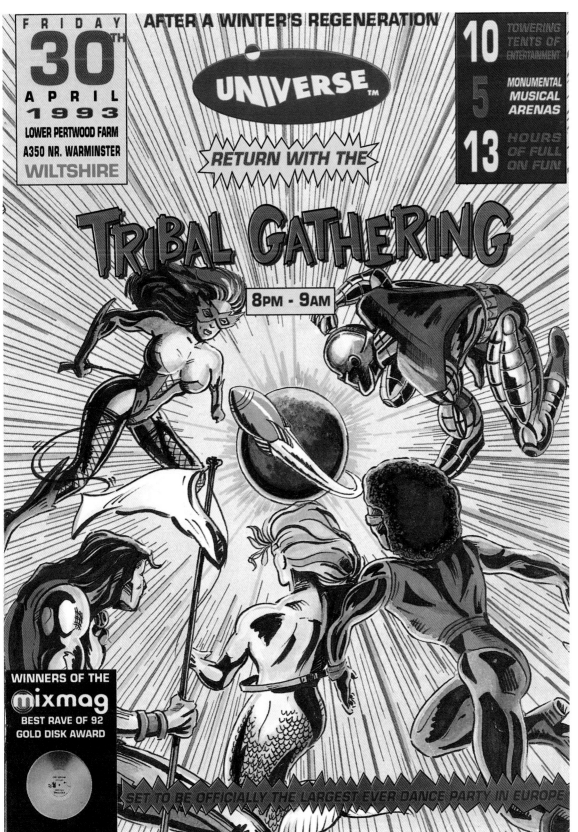

Tribal Gathering
Design. Michael and Oli
Date. 1993
Site. Lower Pertwood Farm.
Wiltshire
eight page leaflet

The Book Of Love
Design. Adrenalin Corporation
Date. 1992
Site. Brayfield Stadium.
Northamptonshire

Amnesia House once held a very famous party called The Book Of Love, which
was the first wedding rave to ever take place. One of the guys, Micky Lynas,
decided to get married in front of 1,500 people. He had a priest on stage and
everything. The club was like a big family.

Carl Cox *Muzik* **010795**

Quest
Design. Adrenalin Corporation
Date. 1992
Site. Quest.
Wolverhampton

Hypnosis
Date. 1988
Site. Academy Palace.
London

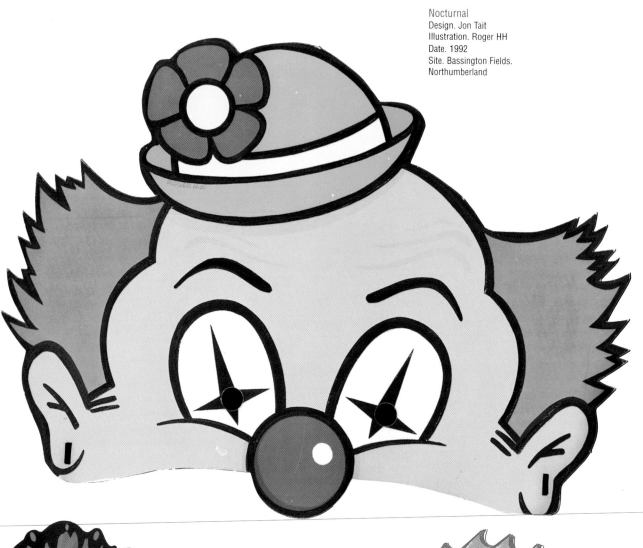

Nocturnal
Design. Jon Tait
Illustration. Roger HH
Date. 1992
Site. Bassington Fields.
Northumberland

Club for Life
Date. 1993
Site. The Gardening Club.
London

Dolce Vita
Illustration. T
Date. 1994
Site. Central Park.
London

Hooked
Date. 1993
Site. La Passerelle.
London

Most Excellent
Design. Craig Johnson
Date. 1993
Sites. Wiggly Worm Club. Manchester
Milk Bar. London
Paradise Circus. Birmingham

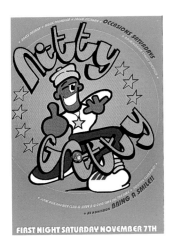
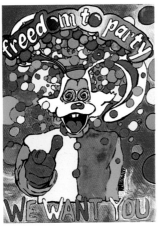
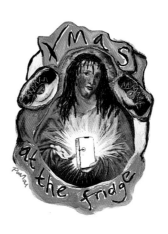
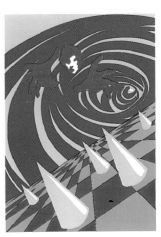

Nitty Gritty
Design. The Designers Republic
Date. 1993
Site. Occasions.
Sheffield

Freedom To Party
Illustration. RM Kingsley
Date. 1992
Site. International 2.
Manchester

Xmas at the Fridge
Illustration. Pamau
Date. 1990
Site. The Fridge.
London

Summer Night's Madness
Design. Mate
Date. 1991
Site. The Wonderland Arena.
London

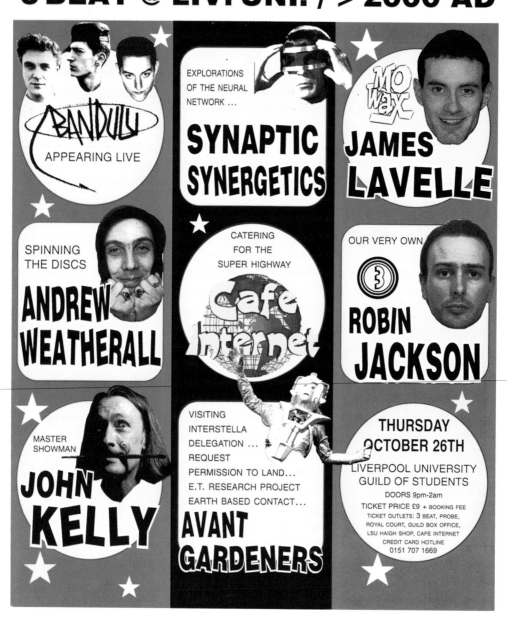

EQUATION

3 BEAT @ LIV. UNI. / > 2000 AD

ABANDU
APPEARING LIVE

EXPLORATIONS OF THE NEURAL NETWORK …

SYNAPTIC SYNERGETICS

MO WAX
JAMES LAVELLE

SPINNING THE DISCS
ANDREW WEATHERALL

CATERING FOR THE SUPER HIGHWAY
Cafe Internet

OUR VERY OWN
③
ROBIN JACKSON

MASTER SHOWMAN
JOHN KELLY

VISITING INTERSTELLA DELEGATION … REQUEST PERMISSION TO LAND… E.T. RESEARCH PROJECT EARTH BASED CONTACT…
AVANT GARDENERS

THURSDAY OCTOBER 26TH
LIVERPOOL UNIVERSITY GUILD OF STUDENTS
DOORS 9pm-2am
TICKET PRICE £9 + BOOKING FEE
TICKET OUTLETS: 3 BEAT, PROBE, ROYAL COURT, GUILD BOX OFFICE, LSU HAIGH SHOP, CAFE INTERNET
CREDIT CARD HOTLINE
0151 707 1669

Equation
Design. Nonconform
Date. 1995
Site. Guild of Students.
Liverpool
front and back

EQUATiON

3 BEAT @ LIV. UNI. / > 2000 AD

FOR ONE NIGHT ONLY

APPEARING LIVE:

SPEEDY J

EXPLORATIONS OF THE NEURAL NETWORK ...

SYNAPTIC SYNERGETICS

THE FABULOUS

ROOTSMAN

RITCHIE HAWTIN

CATERING FOR THE SUPER HIGHWAY

Cafe Internet

THE MINDWINDER

IN PERSON

JUDGE JULES

VISITING INTERSTELLA DELEGATION ... REQUEST PERMISSION TO LAND... E.T. RESEARCH PROJECT EARTH BASED CONTACT...

AVANT GARDENERS

THURSDAY NOVEMBER 30TH

LIVERPOOL UNIVERSITY GUILD OF STUDENTS
DOORS 9PM-2AM
TICKET PRICE £9 + BOOKING FEE

TICKET OUTLETS: 3 BEAT, PROBE, ROYAL COURT, GUILD BOX OFFICE, LSU HAIGH SHOP, CAFE INTERNET
CREDIT CARD HOTLINE 0151 707 1669

Cream
Design. Fab
Photography. Roger Sinek
Site. Ku Club. Ibizia
Date. 1995

Design. Farrow
Date. 1994
Site. Nation.
Liverpool
opposite top left

Design. Fab
Date. 1995
Site. Nation.
Liverpool
front and back
opposite

Flyers are very important. They are the vital link between promoter and customer. The aim of Cream flyers is to give further exposure to Cream's name and logo as a brand, whilst showing the DJ and artiste line-up in a clear and eye-catching manner.

Alan Green Cream **160895**

9294

Double Cream The Second Anniversary

Friday 14th October. 10pm till 6am.	Saturday 15th October. 9pm till 6am.
Residents Paul Bleasdale, James Barton & Andy Carroll With David Morales Paul Oakenfold Graeme Park Jeremy Healy Justin Robertson Jon Pleased Wimmin CJ Mackintosh Dave Seaman Norman Jay MC Kinky + A Very Special Guest	Residents Paul Bleasdale, James Barton & Andy Carroll With Paul Oakenfold Sasha Mike Pickering Pete Tong Andrew Weatherall Danny Rampling Justin Robertson Jon Pleased Wimmin CJ Mackintosh Dave Seaman + A Very Special Guest

Tickets £20 per night or £35 for both nights.
Nation, Wolstenholme Square, Liverpool.
Tel & Coaches: 051 709 1693
Info: 0336 424138 calls cost 39p min rate/ 49p min all other times

cream

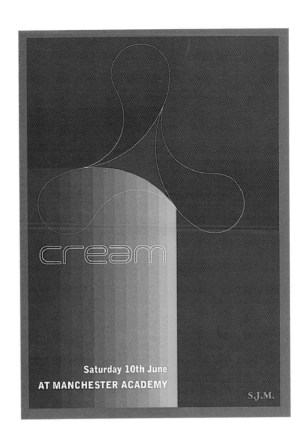

cream

Saturday 10th June
AT MANCHESTER ACADEMY

S.J.M.

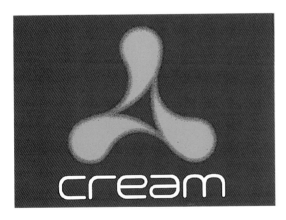

cream

cream

Saturdays June

Residents: Paul Bleasdale, James Barton, Andy Carroll.
Regular appearances: Matthew Roberts Live Percussion: Sudha

June 3rd	June 10th	June 17th	June 24th
Danny Rampling Andrew Weatherall MC Kinky	John Digweed Justin Robertson Paul Harris	Paul Oakenfold Stuart McMillan Orde Meikle	Boy George Jon Pleased Wimmin Judge Jules

OUT NOW! 'CREAM LIVE' DECONSTRUCTION RECORDS
Producers: P. Oakenfold, P. Tong, G. Park, J. Robertson. Double CD Double Tape 35 Tracks

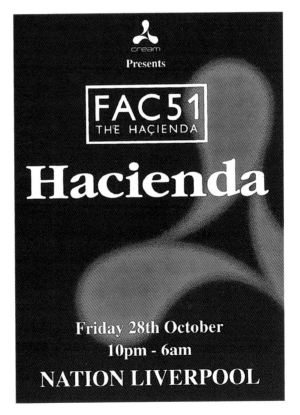

cream

Presents

FAC 51
THE HAÇIENDA

Hacienda

Friday 28th October
10pm - 6am
NATION LIVERPOOL

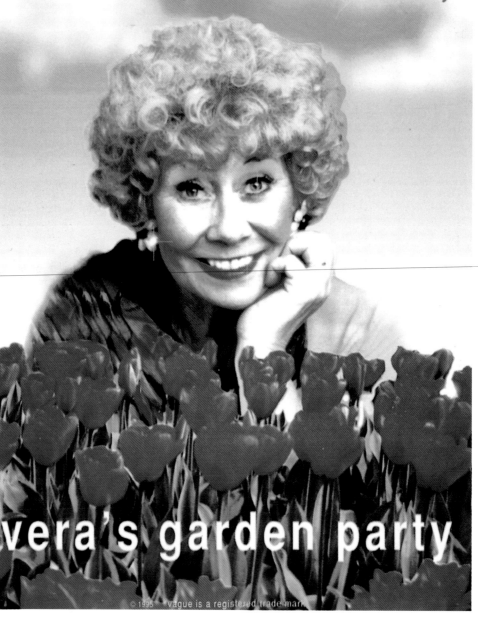

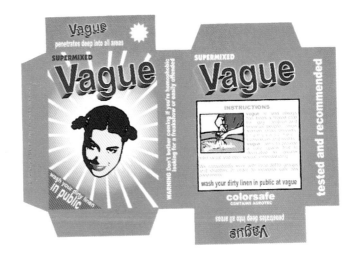

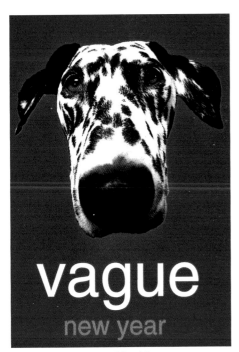

Original photography. Jack Daniels

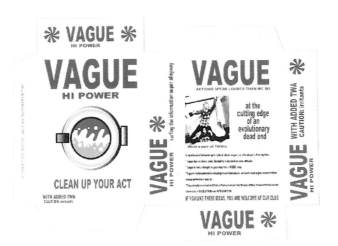

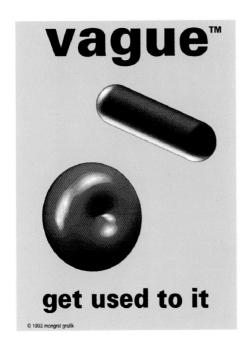

Vague
Design. Mongrel Graphic
Date. 1993-1995
Site. The Warehouse.
Leeds
flyers right unfolded

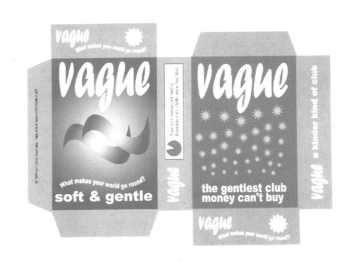

Poodle Parlour
Design. Chris Priest and Craig Richards
Date. 1995
Site. Park Royal Studios.
London

Planet Georgie
Design. Chris Priest and Craig Richards
Date. 1995
Site. Park Royal Studios.
London

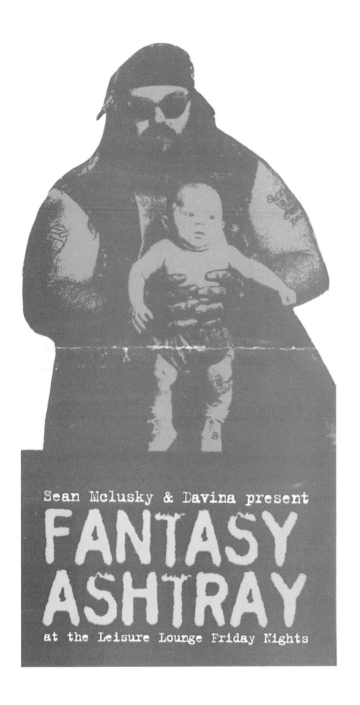

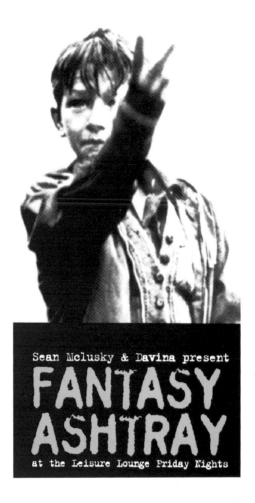

Fantasy Ashtray
Date. 1994
Site. Leisure Lounge.
London

Malibu Stacey
Design. Chris Priest and Craig Richards
Date. 1995
Site. The Hanover Grand.
London
front and inside
unfolded

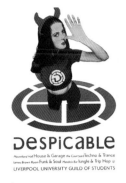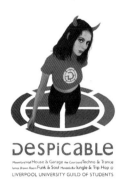

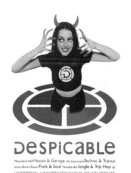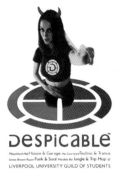

Despicable
Design. Nonconform
Photography. Roger Sinek
Date. 1995
Site. Guild of Students.
Liverpool

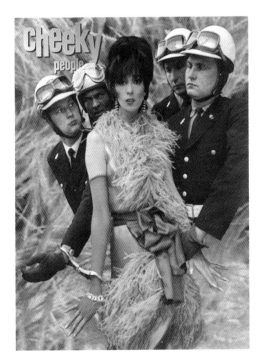

Cheeky People
Design. Andrew Grahame and Byron Mayes
Date. 1994
Site. The Cross.
London

The Cheeky People flyers were always designed with the older, glamorous, more discerning clubber in mind. The kitsch, slightly camp design and intelligent humour of the flyers side-step pretension and reinforces the up-market party style image of the night. The Cheeky People flyers won "Flyers of the Year 1994" - awarded by *Timeout* magazine, and "Best flyers" - at the London Club Awards 1995.

Andrew Grahame Goodtime Promotions **140895**

Nuff Ballroom
Design. Eg.G
Date. 1993
Site. City Ballroom.
Sheffield

Wild Fruit
Design. Mainartery
Date. 1994
Site. The Paradox.
Brighton

Design. Peter Hayward at Mainartery
Date. 1995
Site. Discoteque Royale.
Manchester

Some flyers are amusing - you know the funny ones. But on the whole they are just for the information and nothing else. I've never collected them, I couldn't tell you what my favourite flyer is and, to be honest, I've never thought about how important they are anyway.

Jeremy Healy **270795**

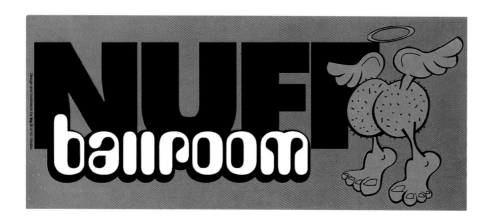

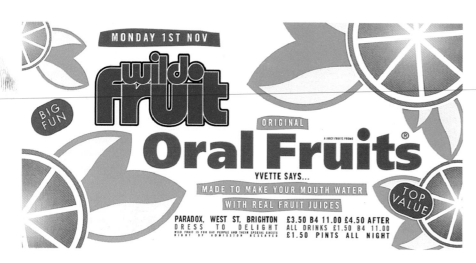

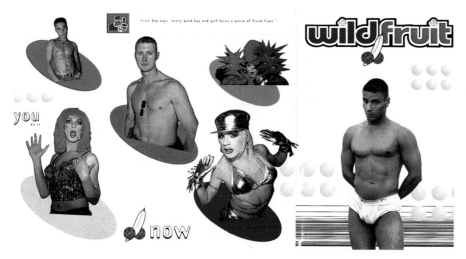

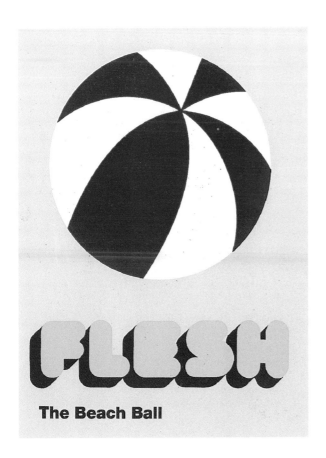

The Beach Ball

Flyers have always been important. The first rule of club promotion: No flyers = no customers = no club! There may be exceptions to this rule but there are not many. Think of a club which is successful and you will be thinking of a club that has effectively branded its image on a flyer.

Paul Cons Flesh **070895**

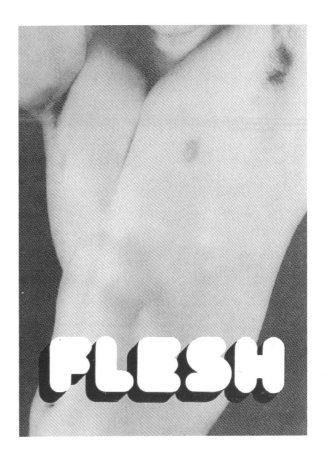

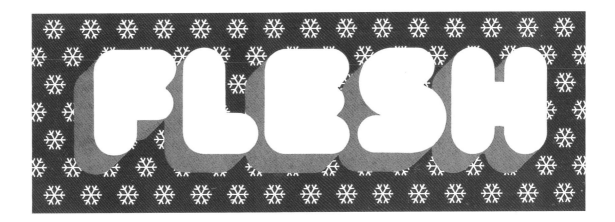

Flesh
Design. Craig Johnson
Date. 1994
Site. The Haçienda.
Manchester

Wobble
Design. Phil Gifford
Date. 1993-1995
Site. Branstons Venue.
Birmingham

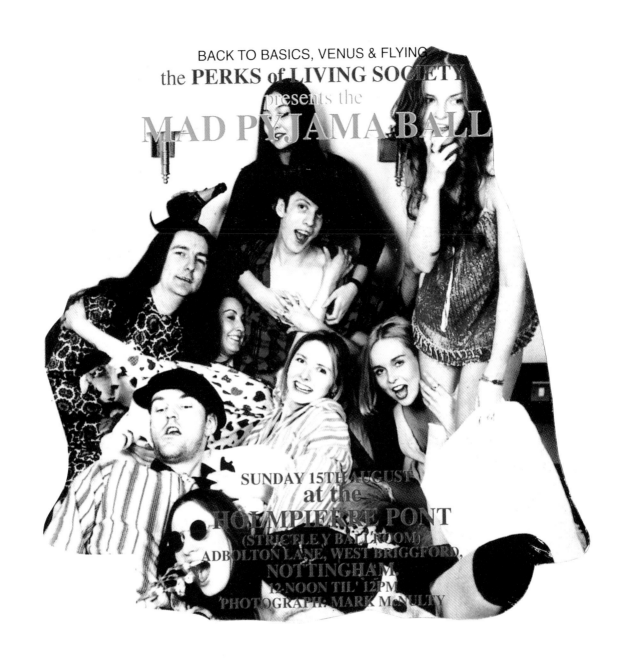

Mad Pyjama Ball
Design. AR:5E
Photography. Mark McNulty
Date. 1992
Site. Holmpierre Pont.
Nottingham

lovesexy lovesexy lovesexy lovesexy lovesexy lovesexy lovesexy lovesexy lovesexy lovesexy lovesexy lovesexy lovesexy lovesexy lovesexy lovesexy lovesexy lovesexy lovesexy

LS f/y,06.

Bakers.
162 broad st.birmingham.
every friday,ten till late.
£6 members/NUS.£8 non members.
(tel:01216333839)

playing house divinyl

richie roberts

(resident dj)

lovesexy

Bakers The Club.Every Friday.DJ::Richie Roberts
Bringing you the best in house divinyl,live sax and percussion.
Admission £5.00 members £7.00 non members.
Rear patio now open.Sexy mutha funkers.10< >late.Reduced admission with this flyer.

design > egg 021::773::8270

Bakers The Club
162 Broad Street Birmingham
Tel 021 :: 633 :: 3839

June '95

Colours

Colours
Design. Ricky Magowen
Date. 1995
Site. The Vaults.
Edinburgh

Lovesexy
Design. Eg.G
Date. 1995
Site. Bakers.
Birmingham
opposite

Jungle Fever
Design. Pez
Date. 1994
Sites. The Warehouse. London
The Edge. Coventry

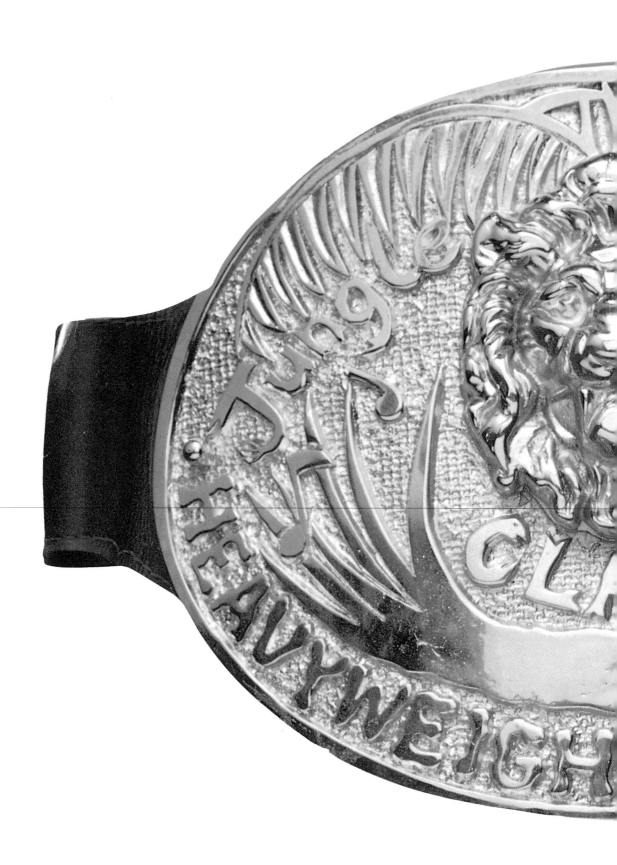

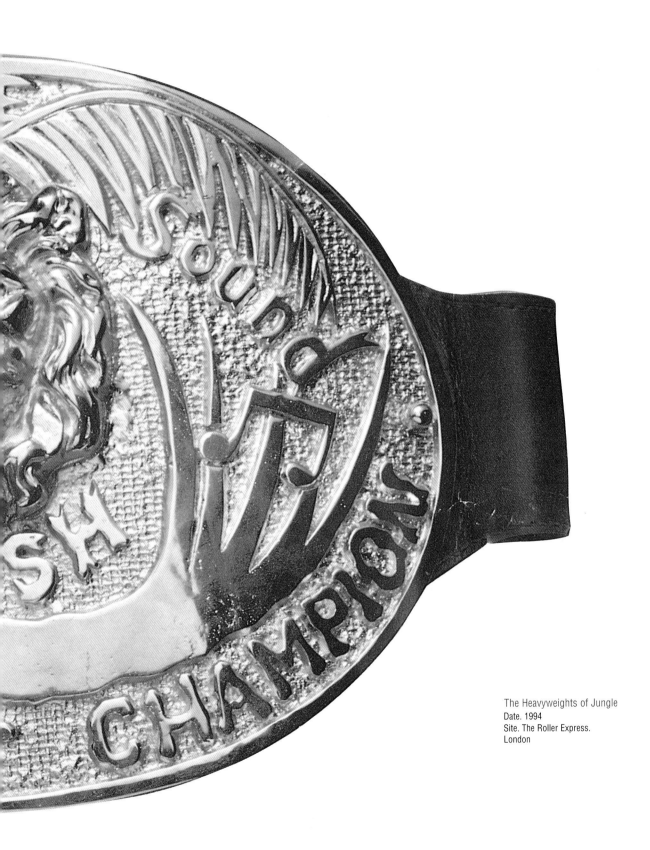

The Heavyweights of Jungle
Date. 1994
Site. The Roller Express.
London

Jungle Fever
Illustration. Malx
Date. 1995
Site. The Sanctuary.
London
unfolded

Way back in the summer of 1991 was the birth of something which took London by storm - Sunday Roast - not roast dinners but Sunday afternoon raving to the best Acid House DJs around. Being nothing but original, Roast introduced MCs which gave the music a new look and a new style. This made the music underground, and unique to the Roast.

Dorothy Roast **230895**

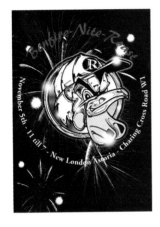

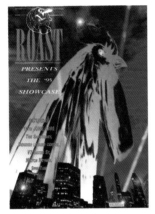

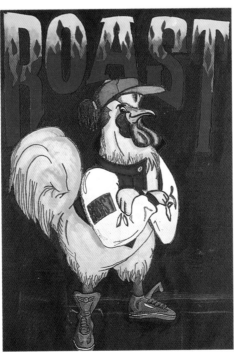

Roast
Date. 1994
Site. Zatopeks.
London
far left

Design. Damon
Date. 1995
Site. New London Astoria.
London

Roast presents Land of the Giants
Design. Damon
Date. 1994
Site. New London Astoria.
London

Design. Damon
Date. 1995
Site. The Sanctuary.
London

2

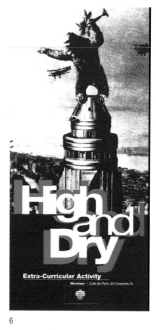

3

4

5

7

1

6

A Snapshot of Club Culture 1995

"The Music Biz corrupted Rock'n'Roll into millionairebels in thousand dollar rags and perms playing revolutionaries for teenage pubescents. Punk turned out to be mostly just the second childhood death throes of Rock'n'Roll after all. But the best stayed true and were still on the road when House came along. House is different. We all feel that. We won't be fooled again..." Fraser Clark: copy on flyer for "Shamanarchy In The UK", Evolution compilation album, 1992.

From Utopia to Fruitopia
A bottle of "real fruit drink" stands on the table. A bottle of watered down, sugary, (10% worth of) juice, with added colouring, citric acid and flavouring. "Fruitopia - Apple and Tangerine Dream". A drinkable, disposable, 3-Dimensional metaphor for the 90s dance movement. Check the bottle: scene buzzwords - body, mind and planet - etched into the glass amidst groovy swirls and stars and bright shining suns. See the ads: kaleidoscopic colours cavorting on screen to trippy sonatas and the promise of bliss..."imagine what it can do for your soul". Read the label: "Fruitopian Life - the apples don't fight the tangerines in fruitopia, people could learn a lot from fruit".

People could also learn a lot from Fruitopia. The graphics and rhetoric have come straight from the acid/Ecstasy/spliff-stoked imagery of festival flyers. It's lifted the Glastonbury vibe, wholesale, to carry a message to a new youth market. Fruitopia - a hyper-researched consumer product made and absolutely manufactured to increase profits for the Coca-Cola corporation, one of the biggest multi-national conglomerates on the planet. Check the bottle. See the ads. Read the label. Swallow the bullshit. From Acid House to citric acid in a decade. Is this the destiny of dance?

Whatever happened to the teenage delirium dream?
The Henley Centre for Forecasting reckons that the rave industry in Britain is currently worth £2 billion a year. More than a million party people attend clubs every week, each spending on average £35. Rave has exploded as a massive commercial market, and corporate sharecroppers are determined to milk the club culture cash cow for all it's worth.

The subversive joke by alternative artists, re-inventing the logos of big brand names to promote nights (Crunchie, Spice, Smarties etc. plates 2, 3, 4, 5), has come full circle with a vengeance. Multi-nationals are busy drafting in a mercenary army of old graphics hands, word wranglers and image cowboys to snare, goad and geld the adolescent dance animal with the rustle of money, every time it pops its head above the underground.

As the house movement has been herded into a capatalist kraal, dance culture's spaced-out souvenirs have also been tamed with the voluntary tagging and branding of big business. Indeed flyers are now slick, glossy advertising accessories pushed out to bring home profits.

A Carlsberg Ice bottle appears on the immaculately designed full-colour, "promotion postcard" for Thunder and Lightning at The Cross. A Stella Artois logo sits prominently on flyers for London's High and Dry (plate 6). The Haçienda bonded with Boddingtons for its Cream of Manchester tour (plate 7). And so it goes on. And on. And on....

"All the groovier brands are looking to piggy-back what they recognise as a really good medium because young people are difficult to reach with conventional advertising tools," explains Mark Whelan of London's Duckworth, Finn, Grubb, Waters agency. "Advertisers are recognising the power of flyers, which are very cost effective and don't suffer from instant dismissal which you get with TV. There's also the whole positive association thing that your name is attached to something which is very groovy i.e. a club name which is a way of life. The benefits to advertisers are obvious." But what are the benefits to clubbers - a reduction in entrance prices? Cream in Liverpool - no flyer sponsorship - entrance fee £8-£10. Love To Be in Sheffield - Grolsch logo slapped on flyers - entrance fee £8-£10.

Meanwhile the creators who helped give club culture its original radical kick are now watering their work down as slaves to the rhythm of reactionaries. "The corporations will always try and undermine what you're doing," explains Simon Taylor, of London-based design collective, Tomato, who began doing flyers for Delirium, Discotheque and HQ and now directs ads for Levi's, British Rail and Sony's Play Station (plate 8). "A lot of people who were at the clubs when it all kicked off in the mid-80s are now

8

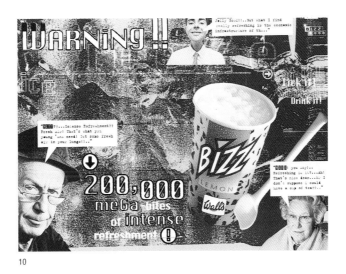

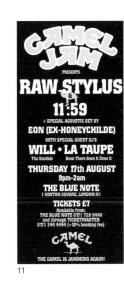

9

10

11

working in ad agencies and design, me included."

Lee Marling of Blue Source, a creative community of 14 full-timers, began doing the Fishtique (plate 9) nights and flyers in London and now not only works on sleeves for Michael Jackson but also handles the marketing strategy and hype for Caterpillar "Walking Machine'". "They wanted the leading edge of youth culture and recognised that we were on the ground rather than using an ad agency which is stuck in an ivory tower" says Lee. Other graphic artists are being briefed to produce straight adverts that look like flyers. A good example is the ad for Wall's Bizz - "a Lemon or Cola flavoured slush with an effervescent kick to it" - which went hard for the feel (plate 10). "A highly targeted PR programme was devised, incorporating Bizz nights at clubs such as The Arches, Ministry of Sound etc. where the product was offered free," says a spokesperson at the SP Lintas agency. "The creative team here set out to produce an ad that doesn't look like an ad...a DIY look that reflects the style of club flyers and posters."

Every brand that needs a bit of hip wants a piece of party action. The Flying Squad is a distribution company which itself has grown with the movement, from a couple of people standing outside clubs handing out flyers, to employing five full-timers and twenty casual staff. Manager, Danny, whose company now give out Get Smart Packs - A5 plastic bags stuffed with flyers - has witnessed the changes over the last five years. "It's amazing how it's come along really, now we don't just give out club publicity in the packs, we include leaflets for records, films, vodka, everything. Everyone has seen the potential in flyers."

Beer monsters, Stella Artois, certainly saw the potential and sponsored the Get Smart Packs for six months. "There's so many clubbers out there it's just unreal," adds Danny. "They're really drinking now and the brewers have recognised the fact."

There's also a lot of clubbers taking drugs who are off alcohol. Millions and millions of them. The multi-nationals are aware of that and are tapping into the trippy flyer imagery too. Enter Coca-Cola's Fruitopia. And Tango's Still. And Lucozade. Or any of the other non-alcoholic, thirst quenchers which are squeezing their corporate fingers around the throat of the market.

"Tango used to be orthodox, then became hipper with a re-designed can and weird promotions suggesting getting out of your head," explains Lewis Blackwell, editor of *Creative Review*. "And that is what Fruitopia, in a more gentle way, is appropriating as graphics - a revival, in a sense, of 60s psychedelia." Or the festival/rave vibe of the 90s. "Drugs are fun and sexy, young people like them and that's why they appeal to anyone who's trying to appeal to young people," argues Mike Linnell of Lifeline, the drugs advice and information centre in Manchester, adding, "Some people might think that's unscrupulous."

Bring on Camel cigarettes. Banned from hitting a young market directly, they sponsor club nights with their own flyers and run competitions to jazz up packs for art students (plate 11). "It's part of either a general strategy, or an amazing coincidence by Camel, of quite carefully selling their cigarettes into youth culture," argues Blackwell.

While the actual market for consumption in clubs itself is quite small, the people who go to the "right places" are influential style leaders and trends established at party nights soon find their way into the mainstream. We've seen it with clothes. We've seen it with bottled water. We've seen it with sounds. To the hipper brands club culture, its language and imagery are now crucial. And it's not just in Britain. Matthew Colin, describing Berlin's Love Parade in *The Observer*, wrote:

"German rave flyers started to look like Formula One Cars, spattered with corporate sponsors' logo. This was no more apparent than at 1992's Love Parade, when Philip Morris saturated the party with promotional material and give-away packets of fags. This year, Camel cigarettes set up booths along the Ku'damm offering free water alongside heightened brand awareness. From a British perspective, this sponsorship appears incongruous and somewhat distasteful."

From a "British perspective", the multi-nationals and huge corporations have already, distastefully, moved in on the club scene, using the influence of flyers all along the way. But does it matter? Apart from taking the vibes of the original movement and perverting them to sell sugary drinks, slush, weak ale and bank interest, there's the view that sees the whole enterprise as exploitation on a huge scale. *Creative Review*'s Lewis Blackwell calls it

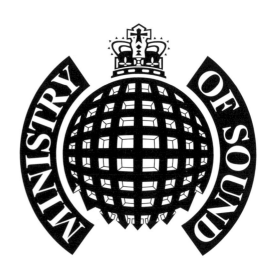

the "farming of clubbers". "That's what they're doing. When you're marketing something you are trying to farm a particular community, you're trying to take their money off them. You see that they have a certain spending power and certain tastes and try to exploit that. It might be seen as reprehensible describing people as a culture which can be farmed but you could put it another way and say the corporations are meeting the wants and needs of people. It depends the way you want to see it." So which way would Blackwell see it? "Now, if they were providing wholesome sandwiches for these clubbers you'd say they were meeting their needs," he laughs. "But the fact is they're providing a highly-profitable, some would say, low quality, drink or cigarette and you tend to see that as exploitation."

Way back when, flyers in their own little way were subversive, pirating established brand names for club images, concealing drug references in the artwork and promising an escape from bland, poverty-ridden Tory Britain. Club culture used to talk a lot about "freedom". It's turning out to be the freedom to be farmed.

From flyers to fly jackets...
"You can't have a perfect club in an imperfect society. You have to change society." Fraser Clark

Music? Did someone mention music ? No. Marketing and merchandising are the buzzwords of the superclubs, those whose name alone is guaranteed to draw a huge crowd. Wise that their flyers have a certain prestige attached, that being seen with one sticking out of your pocket says loads about you, the superclubs are cashing in.

Logos are now lifestyle symbols. And whereas the odd club artwork used to appear on t-shirts they now adorn whole ranges of designer clothes, record sleeves and full-page glossy ads, as well as flyers. "Image, marketing and branding of the club is extremely important," explains Cream's promotions manager, Alan Green who works closely with in-house designer, Ian Whittaker, on graphics and merchandise. "It's like any other designer label. People feel cool if they wear the logo on something."

The point is echoed by designer Mark Farrow, who created the Cream image and intended it to work as a corporate logo. "People aspire to the

look in the same way they want to wear Adidas or Nike and that's why it works so well," he explains. But those 80s young fogey notions of "aspiration" and "lifestyle" - isn't that what rave was supposed to be kicking against ? "I suppose it was really, I very much thought of it as the new Punk," he sighs, "it isn't now...but it makes me a lot of money so I'd be lying if I said it wasn't doing me a lot of good."

From the Cream empire which now includes a shop, cafe, mail order business - and the club - you can purchase a range of items bearing the logo from jackets to snow-boarding hats to dog tags. And it's an operation that has put the Liverpool dance house, which originally only happened on one Saturday night a month, into the superclub bracket.

Now employing thirty full-time staff with a £multi-million turnover and plans for merchandising outlets in every major city, Cream is happy to acknowledge the role flyers have played in its success. "The flyers have been so successful that now we don't even need to have the Cream name underneath the logo," says Alan. "People just know it's us." (plate 12)

And so to the Ministry of Sound in London, who put so much emphasis on their artwork that they employ two in-house designers (plate 13). "It's crazy how it's developed," says Thomas McAllion resident Ministry graphics man. "Originally we just bunged a logo on a t-shirt, then we got together a lot of the flyers we'd been using and bunged them on t-shirts. Now it's developed into designing purely for the t-shirt. The merchandise went off on its own."

The Haçienda, the best-known of dance culture's brand names, is also branching out with a full range of club couture. Its famous flyers have established an identity of cool design, exclusivity and product quality which it's now eager to market.

Indeed, the superclubs are now acting like powerful corporations, but their brand names are already established in the target marketplace. Whereas the fizzy drink people and banks are paying millions to gain credibility, these clubs already have it in abundance. They've got the trust. But how long can it last? We're no longer talking "attitude", "subversive imagery", "danger" and "excitement" in the same breath as club culture. We're talking

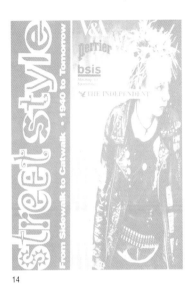

14

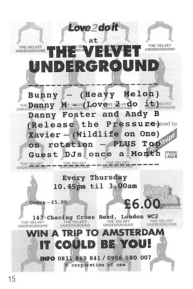

15

16

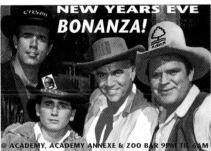

about clubs putting out albums and embarking on nationwide and European tours. We're talking big merchandise operations. We're talking Rolling Stones mentality - the very opposite of what drew people to the scene in the first place. It's all going as stale as a warm Bizz and, maybe, the flyers are beginning to reflect the situation.

Flyers - the glossy end

In a culture that desperately seeks to martyr itself during the lunchtime of its own legend, old flyers are already being avidly collected, exhibited and eulogised. The Haçienda's "greatest hits" were on display back in 1992 in the Sublime exhibition at Manchester's Cornerhouse, while the Victoria and Albert Museum in London presented a collection as part of its Street Style show in 1994. The Victoria and Albert continues to collect and save the vibrant urban artifacts as a spokesperson explained, "They're going to be seen as an important section of youth culture in years to come." (plate 14)

But the best exhibitions of dance culture's calling cards are those nostalgically framed on bedroom walls or pinned to old kitchen notice boards all over the country. "Nostalgic" because, for many involved in that original "Summers of Love" scene in the late 80s, the creativity has died as the House and garage movements have gone mainstream. "I've got a huge amount of flyers," says collector Matthew Acornley. "We used to go out in 1988 and 1989 and pick them up in obscure record shops because you just wouldn't see these parties advertised in *Mixmag* or wherever. Now, the artwork's not half as good as it was and it doesn't follow any more that if the flyer's good the club will be good. I don't even look at them any more."

Talk to anyone who has been there from the start and they'll underline the point. "When the dance thing got huge, flyers got really sophisticated, full colour, really expensive and double sided, even cardboard," recalls Tomato's Simon Taylor. "They looked like record covers in their own right and in a way that wasn't interesting because it was about something else."

And again...."Flyers are crap at the moment, they're going through a really dull period," argues Jim Hollingshead of Verso in Manchester who designs for local club Sankeys Soap. "The golden era was the late 80s and early 90s when the design was anonymous and certain clubs had certain feels."

In an effort to be different some promoters have embraced gimmicks in order to re-fire the imagination of potential punters. Icon in Liverpool gave out sticks of rock for their opening night, London's Velvet Underground went for scratch cards (plate 15) and Pushca's Vanity Fayre dished out spectacle and cosmetic cases. And then there's Pollen who have handed out everything - from bubble bath bottles to voodoo jelly babies with pins stuck through them - to promote their events. "I think that if you come out with something that makes people stop and go 'What the fucking hell is this?', then it probably means you've got a bit of imagination," argues Rollo, co-promoter of small scale Pollen nights. "What's happening now is that someone goes to a graphic designer and says, 'Do me a flyer' and the guy goes 'OK'. Flyers done on Apple Macs are more suited to clubs where you go 'Right, let's make some money, right, what DJs are going to fill our club?'"

As that money has poured into the movement there's been a drive to move up-market by the superclubs who have either got their own full-timers dreaming up designs or have gone to out-siders, top graphics people, for state of the art images. The results are sublime, glossy, expensive graphic masterpieces which say less about the night and more about the clubs' self-perceived elite status.

It's advertising behaviour learned from perfume houses and cigarette companies. And, in line with bourgeois brand advertising, people are beginning to question the hype. Meanwhile, medium scale clubs seem to be following, putting design out to graphics companies who also work on corporate accounts. The results are clean designs, devoid of originality.

As ideas dry up, house and techno flyers, like mainstream agency advertising generally, are embracing retro, kitsch and sexist imagery (plates 16) - light years away from the wild graphics which brought flyers to the notice of discerning viewers in the first place, and set them apart from mere "leaflets". The two slick mediums, corporate advertising and flyers, which were once at opposite ends of the aesthetic scale are now looking indistinguishable. But now all conventional campaigning is being threatened by new technology....

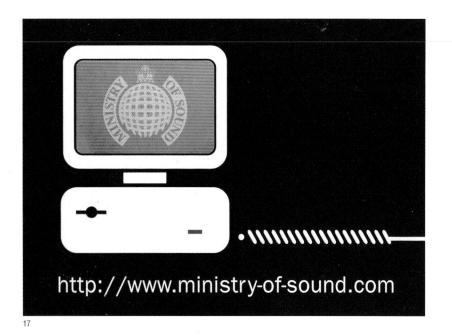

http://www.ministry-of-sound.com

17

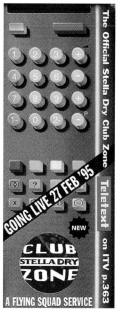

18

Cyber flyers - the final frontier

The Net. The sexiest new gizmo on the planet, as the incredibly late 20th century puckers its last pout. An info super-highway, making paper and plastic flyers come on like horse and carts in the slow lane of the mega-electronic age (plate 17). Home Pages, Web Sites, E-mail. Clubs are in the forefront of the dash to flash virtual flyers across the globe, hitting a potentially huge partying population. Is this the end of printed flyers as we know them?

Apparently not. Even though clubs are wiring-up, their clients aren't switching on. Affordability remains a problem. Access remains a problem. Hi-tech illiteracy is another problem. And general apathy to the Net remains a constant. Around the spate of cyber-connected cafes that have sprung up people are tuning in but club pages are rarely on the agenda. "People just tend to surf the Net rather than checking out club nights," explains Mark Sullivan, bar manager at Dry in Manchester who have the software installed and available for a small fee. "They know all about the nights they're going to and they're still picking up flyers."

Indeed, despite the malaise that flyer art finds itself in, no-one seems to be over-enthralled about the Net's prospects. "I'm not wowed with it at the moment," says Danny of The Flying Squad who's taking one technological leap at a time, "we're concentrating on electronic flying through Teletext because that's free, every telly has got it and we're getting 78,000 people a week tuning in. We're also still giving out our Smart Packs." (plate 18)

Meanwhile in the underground, free festival organisers are having second thoughts about the new tool. In July 1995 police broke up a Mother rave, the first big party since the Criminal Justice Bill became law. *Mixmag* reported: "A Devon and Cornwall Police spokesman described the costly operation as being 'a success'. He added that the police had acted on intelligence which had included information found on the Internet. Ironically the freedom of access afforded by the information super-highway proved costly."

Logistically, conventional flyers will survive, according to legendary punk promo originator Jamie Reid. "Flyers will always be around because they're fast, cheap and effective. When we first started we produced simple black

and white images which spread from town to town as people photocopied them and passed them on. Personally I prefer stickers, which are far more obnoxious, because you can go around sticking them on tube escalators and places. The Net doesn't get you off your arse." For others it's the aesthetic value of flyers that will ensure their survival. "I think they'll last because people like to collect things especially if they look nice," ponders Mike Linnell of Lifeline who use flyers to get their drugs information and advice across. "It's the stamp collector and train spotter at work in the British psyche." (plate 19)

Ultimately, the potential for virtual flying will depend on how widely available the technology will become. "There's no easy access for average club goers," concludes Mark of Dry, "it's business people who have the most access to the Net." Which might explain the superclubs' fascination with it.

Whatever happened to the teenage delirium dream?
Epilogue: from Fruitopia to Utopia

"The fact that you can now do a book on flyers is like the whole scene anyway," argues Matthew Acornley, average raver and flyer collector. "There's rave compilation albums being advertised on telly, clubs putting full page adverts in *Mixmag*, there's a whole industry growing around it."

Flyers tell a story. And the story emerging is yet another episode where a youth cult, enslaved to corporations, is becoming a bastion of bland conformity. Where those once feeding the energy of the movement are now the establishment. And where those looking for the withering energy are being farmed for their money as they dance to the clinking-clanking sound of commercial cash tills.

We've seen it all before. The 60s hippies. The 70s punks. Is it inevitable that rave culture will collapse under the weight of the same contradictions? From underground, to mainstream, to staleness, to death, to be dug up in years to come for retro exhibitions and TV documentaries.

Paul Mason, director of the Haçienda, has seen the E-generation grow from the start. "People have been there, done it and get jaded very quickly," he explains. "The vibe's all gone now. I think there's a cycle and I think we're

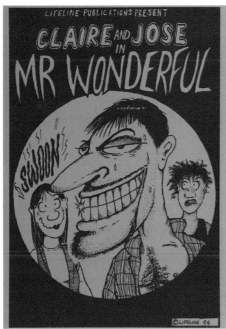

19

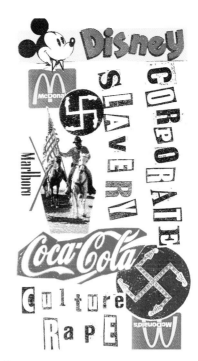

20

about due for another one. I'm looking to see what's coming next. Whether people say they're in it for the love or whatever, we're here to earn our living aren't we?"

It's easy to be cynical. But dance differs from Punk and hippy. It's not Rock'n'Roll. It's a whole new genre. And within that genre the movement has already fragmented into different styles and attitudes. While House dominates the present mood with its kitsch campaigns, on the underground the seriously kicking clubs have gone back to scruffy black and white flyers, reflecting a rejection of all that the club culture industry has become.

"No corporate bastard will be able to pull that on me again," seeths Fraser Clark, who's new age consciousness night, Megatripolis in London, was hijacked and subsequently bankrupted by two partners, one of whom was an associate of Rothschild Bank. "They cut through us like a hot knife through butter but we learnt a lesson in reality" he adds. "We're setting up another small adventure, the Parallel University, with one colour flyers and when people arrive they'll find not only a rave but lectures, talks and debates - the first one has the motion 'The Alternative Movement Has No Place in Clubland'..."

When the E-generation first appeared, love-hearts, flowers and sensual Eastern symbols spoke louder than words as the imagery on flyers was only tapered by the limits of the imagination. Hugging and dancing into a new consciousness, people really did think they could change the world back into the wonderful, beautiful place that it once was.

But whereas over the last ten years those sentiments confined themselves to fantasy art on dance culture's calling cards, now the statements are being put into practice in the real world. There's a bright new consciousness in the air for the greatest revolution, united by a "repetitive beat" and unpretentious flyers that appeal to the heart and soul rather than attempting to sell a fizzy drink.

New sound systems are bringing a fresh anti-materialist attitude to dance. Desert Storm in Glasgow and Demolition in Manchester are trucking out to Bosnian war zones risking their lives for rave, the Exodus Collective in

Luton have linked "community, housing and seriously kicking parties" while United Systems in London are pushing free-party politics centre stage and making them "hip" again. "It's already meaningless to say that a person is a squatter or a road protester, a raver or a traveller" their spokesman, Nic, told *The Face* (Sept 1995) "These are not isolated groups any more. The Criminal Justice Bill has brought everyone together in defence of their rights."

The Criminal Justice Bill has meant that dancing openly and in large numbers is a crime against the state. Defiant dancing really can change the world now. Rave has become politicised and it's unsponsored flyers articulate the feel, led by punk protagonist Jamie Reid and his "Corporate Slavery" image. (plate 20)

The most unhip historical man of the moment, Leon Trotsky, once wrote, "In the realms of artistic creation, the imagination must escape from all constraints and must under no pretext allow itself to be placed under bonds. Spiritual creativeness demands freedom." Flyers are mere pieces of paper. It's what artists do to them and what they represent that makes them magical. You can never have a perfect flyer in an imperfect society. You have to change society.

PLATES: 1 Frutopia (*bottle label*) 1995. **2** Crunchie 169 Fore Street London. A Blastoff Production. **3** Rava 1992 The Drome Farnworth. **4** Smarties Rockworld Manchester. Designed by Shane. **5** Spice Linford Film Studios London. **6** High and Dry Cafe de Paris London. **7** The Cream of Manchester Tour 1993 The Haçienda Manchester. **8** Sony "The Power of Playstation" by Dave McKean 1995 (*postcard*). **9** Fishtique Woody's London. Designed by Lee Marling. **10** Bizz (*magazine advert*) 1995. **11** Raw Stylus 1995 The Blue Note London. **12** Cream logo. Designed by Farrow. **13** Ministry of Sound logo. Designed by Mervyn Rands. **14** Street Style 1994 Victoria and Albert Museum London. Designed by Colin Corbett (*leaflet*). **15** Love 2 do it 1995 The Velvet Underground London. **16** Midnight Mass 1995 Caligari Luton. Designed by Wideboys. Glitterati 1995 The Cross London. Designed by Jonathan Cuttings. Bonanza 1993 Academy Liverpool. Designed by Shed. **17** Ministry of Sound 1995 (*magazine advert detail*). Designed by Thomas & Thomas. **18** Club Zone 1995. **19** Lifeline 1994. Illustrations by Mike Linnell. Written by Michelle Durkin (*leaflet*). **20** Corporate Slavery 1994 Designed by Jamie Reid.

Thank You for the Music

dtobasics

forever young

Forever in our Hearts
Alistair Cooke '65-'93